UNION STATION

in

DENVER

Rhonda Beck

THE
History
PRESS

Published by The History Press
Charleston, SC
www.historypress.net

Copyright © 2016 by Rhonda Beck
All rights reserved

First published 2016

Manufactured in the United States

ISBN 978.1.62619.964.4

Library of Congress Control Number: 2015955230

Union Station served as the heart of Denver from opening day in 1881 until its eclipse by automobiles and aviation. Rhonda Beck tells the heartening story of Union Station's resurrection.
—Professor Tom "Dr. Colorado" Noel

CONTENTS

FOREWORD

To tell the story of Union Station, you need to look at the entire core of Denver's downtown and its transformation since the 1980s.

Today, the downtown area is envied by cities nationwide because of the established housing, restaurants, bars and businesses with nearby amenities of sports, art, music and flourishing city parks. But thirty-five years ago, the Central Platte Valley just west of downtown was littered with abandoned railroad yards, decaying buildings and open space often filled with trash and homeless camps.

And among the neglect to the east in Lower Downtown (LoDo) was the once vibrant Union Station depot, which played such a vital role in the history of the railroad in the Mile High City.

Mayor Federico Peña began the cleanup of the area in the 1980s, when he served two terms as Denver's first Latino mayor with the motto: "Imagine a Great City." When I was elected in 1991 as the city's first African American mayor, my goal for the valley and downtown was to build that great city.

I knew the first place to start was with our struggling downtown, where most businesses closed their doors at 5:00 p.m. My first official action as mayor was to call for a Downtown Economic Summit. We gathered property owners, store owners, individuals with leases and others interested in revitalizing downtown.

We worked on the issues of how to keep downtown safe, how to deal with cleanliness and how to attract new residents. I knew once we attracted new housing, the businesses would come. In 1990, there were 2,700 residences

downtown. That had ballooned to about 8,000 by the time I left office after three terms in 2003.

While we first focused on attracting new housing, we also knew downtown needed to have amenities to attract more visitors.

Other projects that affected the downtown area were cleaning up the South Platte River and replacing the nearby wasteland with ninety acres of new city parks, including Confluence, Cuernavaca and the thirty-acre centerpiece, Commons Park. Additionally, the city, in partnership with developers constructing new housing in the Central Platte Valley, built the $3 million Millennium Bridge to connect the valley with downtown.

I also made sure that the city's professional sports teams—the Denver Broncos, Denver Nuggets and Colorado Avalanche—signed contracts to stay in the Platte Valley for at least twenty years. And we passed bonds to raise money to improve the Denver Art Museum and Colorado Convention Center, in addition to getting the new Hilton Hotel built.

And in 1995, Coors Field opened as the home of the Colorado Rockies, which spurred more housing and business development in other abandoned industrial areas.

While these projects were underway, I also knew we had to find a way to bring the Union Station depot back to life. The wonderful historic building needed to return to the transportation hub it once was, and my administration began that work.

We spent several years working with the Regional Transportation District (RTD) to relocate the bus terminal from the Sixteenth Street Mall to Union Station. To allow that to happen, RTD had to purchase the depot from a private developer. When RTD came up short for the $60 million purchasing price, I worked with city staff to find an additional $7 million to allow the transaction to be completed.

My administration, including chief of staff Wayne Cauthen and the late Jennifer Moulton, my planning director, helped get all the pieces in place for the depot to be revitalized.

I felt proud to see the seeds of the project finally come to fruition in 2014 at the ribbon-cutting for the $300 million renovation. Union Station is once again a jewel for the Mile High City.

There also is a personal aspect of my desire to preserve Union Station. The railroad has been a continuous part of my life, from my father, Marion Wellington Webb, working for the Chicago and North Western Railroad for forty-two years to my travels by train when time allows. It is a wonderful way to see the country.

FOREWORD

I applaud author Rhonda Beck for her research, interviews and writing. It is not easy to condense more than one hundred years of history into a book. She has successfully informed generations of readers about the birth and rebirth of Union Station.

Much like traveling by train, readers will enjoy weaving through the journey of how the station has survived fire, relocation, blizzards, storms, two world wars, neglect and its final destination of revitalization.

WELLINGTON E. WEBB
Denver's mayor, 1991–2003

ACKNOWLEDGEMENTS

There are many to whom I owe gratitude:

Tom Noel, "Dr. Colorado," for suggesting I should take on this project. Thank you for believing in me.

Authors Charles Abi and Kenton Forrest, whose book *Denver's Railroads: The Story of Union Station and Railroads of Denver* was my bible for the original station's history, and again to Charles Albi, for his support, manuscript review and encouragement.

Fellow postcard collector and friend Bill Eloe, for allowing me to scan and publish his rare Jackson and Alex Martin stereo cards.

Author and dear friend Beth Sagsetter, for her proposal and marketing ideas and support throughout the entire project; along with her husband, Bill, she drew me in and taught me so much about Colorado's mining history, inspiring me to continue researching this state's rich past. Beth, please accept my greatest appreciation and thanks for the inspiring conclusion of this story. The Sagsetters are authors of *The Mining Camps Speak*; *The Cliff Dwellings Speak*; and *Side by Side: A History of Denver's Cofield Historic District* and owners of Benchmark Publishing of Colorado.

Krista Slavicek, acquisitions editor at The History Press, who patiently worked with me to submit the images and manuscript and finish this project.

Becky LeJeune, commissioning editor at The History Press, who was a delight to work with during the proposal phase of this adventure.

A friend of many years, Lola Wilcox of White Raven Enterprises, Ltd., for manuscript review and for always encouraging me in any endeavor I've taken on.

ACKNOWLEDGEMENTS

All the wonderfully helpful soles at the Western History Department of the Denver Public Library and especially Bruce Hanson, although now retired, and Roger Dudley, who always were enthusiastic about my historic research and ephemeral finds.

Kate Davis of Sage Hospitality, for sharing the beautiful construction photo gallery by Ellen Jaskol Photography and escorting me and Gary Hubel into the non-public places for opportunities to photograph some of the wonderful hidden treasures of Union Station.

Gary Hubel, friend and photographer, who took pictures of the once hidden historical artifacts, such as the baggage claim checks, basement vault, train scrolls and celebrity photographs.

Jessie Howard and Wellington Webb, for sharing stories of their families' involvement with the railroad. Jessie, thank you for the tunnel sketch.

Friend and photographer Lori Warner, for taking the author's photo.

Bill Moon (with assistance from Kate Lucks and Brittany Torres) of Tryba Architects, for a phone interview about the challenges of building out the hotel and renovating the station, as well as partnering with me for submitting a proposal to Colorado Preservation, Inc., for a "Saving Places" breakout session.

Wellington Webb, for a face-to-face interview about his father's career with the railroad and for the insightful foreword.

Jerry Nery, Denver Union Station project manager, for all his extra efforts and assistance with the Union Station logos, much-needed contacts with others involved with the project and encouragement; he gave not only to me but also to others who helped make this story available to the public.

Thank you, Bob Aguirre, for all the ebay bidding and ephemeral shopping you do on my behalf.

THE FINAL SPIKE

DENVER GETS A RAILROAD

Early in the fall of 1858, St. Charles was established as a settlement along the east side of Cherry Creek. Just a few weeks later, Auraria was established on the west side of the creek. William Green Russell claimed the Auraria site, naming it after the gold mining settlement in his home state of Georgia. During that same winter, Russell and his men went to Kansas, and General William Larimer jumped their claim. Auraria and St. Charles joined on November 22, 1858, to become Denver City, a mining supply town for those in search of gold.

General William Larimer, who named Denver City in honor of the Kansas Territory governor, proclaimed:

> *A railroad is coming. The Pacific Railroad has planned to build through the West...The whole country is demanding that this road be built. The West is demanding it. Denver City demands it...We have laid the foundation for a city, an outlet for this gold bonanza and for the Rocky Mountain region.*

Supplies to Denver City were transported six hundred miles from Leavenworth, Kansas, the nearest town, at great expense and time. The Leavenworth and Pikes Peak stagecoach spent nineteen days crossing the prairie to arrive in Denver City on May 17, 1859. Passengers paid approximately eleven cents a mile for stagecoach fare in the late 1860s and early 1870s. Passage from Atchison, Kansas, to Denver cost as much as seventy dollars per person. Mail was carried by pony express.

There was no doubt that the railroad would greatly improve the lives of Colorado citizens.

Colorado territorial governor John Evans, knowing the importance of the railroad, became Denver's biggest advocate and promoter. Appointed by President Lincoln, Evans, commissioner of the Union Pacific Railway, had previously promoted the railway in his hometown of Chicago.

The 1866 transcontinental railroad decision was to take the easy route to Wyoming instead of tackling the Rocky Mountains of Colorado. Denver citizens rallied. Governor Evans, along with *Rocky Mountain News* owner William Byers and David Moffat, convinced Denver citizens to help raise the necessary money to build the spur to tie Denver to Cheyenne. Moffat, Evans, Luther Kountze and president of Central Overland & Pikes Peak Express Company. Bela Hughes incorporated the Denver Pacific Railway and Telegraph Company with $2 million as capital stock. Fred Saloman, a member of the board of trade and business owner, was among the pioneer businessmen and affluent citizens who invested to make this dream come true.

Banker and, later, Denver-elected city treasurer Luther Kountze organized the Colorado National Bank in 1866, helping fund bridges over Cherry Creek and the South Platte. The bank's safe weighed over 1,800 pounds; it took thirty-five days for twelve oxen to transport it from Omaha to Denver.

The Colorado Central Railroad, founded by W.A.H. Loveland and the citizens of Golden, was competing with Denver to connect with the transcontinental railway. Governor Evans, determined to make Denver the hub, persuaded Congress to grant the Denver Pacific Railway and Telegraph Company 900,000 acres of land with the intent to connect the rail lines of the Union Pacific and the Kansas Pacific.

Some four thousand citizens raised $300,000. On May 18, 1868, ground was broken for the 106-mile spur with construction on each end of the spur. People were so excited to have the iron horse in Denver that they volunteered their labor to grade tracks and cut trees for railroad ties. Trees were removed from the location of what would become the original depot, located at Sixteenth and Wewatta Streets, to make room for tracks.

In July 1868, William Smith, a Colorado pioneer and Denver District elder, wrote in his journal, "The people in Denver are greatly excited about a railroad in Denver. It is an age of meat and drink."

Construction of the railway brought many people to Colorado for work. The last spike, made of silver and donated by the Georgetown mines, was pounded in to complete the rail line. On June 24, 1870, the first train from Cheyenne arrived in Denver at the first rail station, located at the foot of

THE FINAL SPIKE

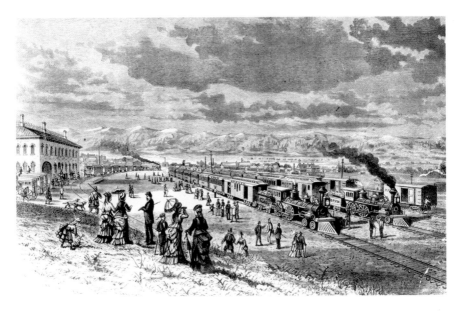

The first three railroads, the Denver and Rio Grande, the Kansas Pacific and the Denver Pacific are showcased in this 1870s engraving of the first railroad station. *Western History Department, Denver Public Library.*

Twenty-second Street, with the first forty passengers. Thousands of proud locals watched and celebrated. Their dream had come true: the iron horse had made it to Denver.

Soon, the rails began to spread from Denver across the state. Colorado could now expand. The first narrow-gauge train ran from Denver to Colorado Springs, as reported by the *Rocky Mountain News* on October 26, 1871:

> *The train was composed of a baggage and smoking car and two elegant passenger coaches, Denver the name of one and El Paso the other, drawn by the engine Montezuma. The train left Denver at 8:00 this morning. A pleasant run was made to terminus of the road at Colorado Springs on regular time, all the guests enjoying the magnificent scenery along the line.*

The railroad brought tourists and new residents, along with much-needed supplies and construction materials to ensure Denver's growth.

Fueled by mining wealth, real estate investors and early pioneers, Denver flourished and expanded. Ten years saw the construction of the Tabor Opera House (opened 1881); Edbrooke's Masonic Temple (completed 1889); Arapahoe County Courthouse, once located at Sixteenth and Tremont

Streets (1883); Brown Palace Hotel (1892); the Capitol (1890–94); and more saloons, hotels and other major businesses. As the city became a bigger tourist destination, it attracted more East Coast investors, such as James Duff, who constructed the Windsor Hotel, which opened with much fanfare in June 1880, just one month after the new depot's foundation was begun.

The Denver Pacific line enabled people to travel from coast to coast, bringing as many as one hundred passengers a day, as well as tons of freight, to the city. It was easy to promote Denver to tourists. Colorado offered three hundred days of sunshine; pure, dry air; clear springs from the mountains; large businesses; beautiful parks; fireproof hotels; fine architecture; thriving mining districts; plenty of watering holes; breweries to quench one's thirst; theaters; and many other forms of entertainment.

Each of the four railroads—the Union Pacific; the Denver and Rio Grande; the Denver, South Park and Pacific; and the Colorado Central—had its own individual station downtown. Passengers had to cross tracks in inclement weather, trudging through snow, mud or dry, dusty, unpaved streets to make their connections.

THREE STRUCTURES

ONE LOCATION

THE FIRST UNION DEPOT: 1880

To complete Walter S. Cheesman's dream, Kansas City architect William E. Taylor was hired in February 1880 by Denver's four railroads and Jay Gould, a New Yorker who financed the project, to develop plans for one terminal station to serve them all. The architectural plans were ready on March 20, 1880. Less than a week later, the Union Depot and Railroad Company of Colorado began construction on the new terminal.

Ground was broken on the foundation of the new depot on May 10, 1880, after ninety-six lots were purchased for just under $100,000, while another $164,000 was paid to constructor James A. McGonigle of Leavenworth, Kansas. Architect Taylor chose the Italian Romanesque style for this grand depot to be built at the far end of town.

Local materials, such as sandstone from Manitou Springs and stone from Morrison, were used. Rhyolite, a rose-colored volcanic stone, was chosen as one of the building materials because it weathers well. The Molly Brown Mansion and Carriage House on Pennsylvania Avenue, Castle Marne Mansion on Race Street and two churches—the Trinity Methodist downtown and the First Unitarian at Fourteenth and Lafayette—were all constructed using rhyolite quarried just south of Castle Rock.

The new depot opened on June 1, 1881, as the largest building west of the Mississippi and was not only significant in size but also in cost. Compared to the construction costs of the county courthouse ($360,000); the Windsor

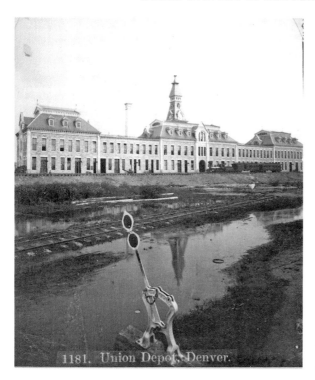

William Jackson's stereo card of circa 1880–81 captures the grand depot constructed at the far end of town where a duck pond previously existed. *Courtesy of Bill Eloe, Englewood, Colorado.*

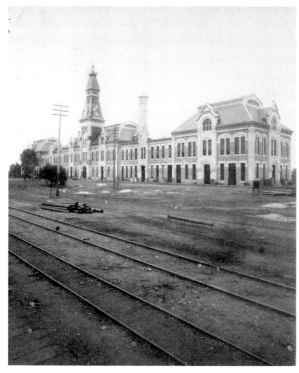

Barren land surrounds the newly constructed depot, built primarily of Colorado materials, as depicted in William Jackson's 1880–81 stereo card. *Courtesy of Bill Eloe, Englewood, Colorado.*

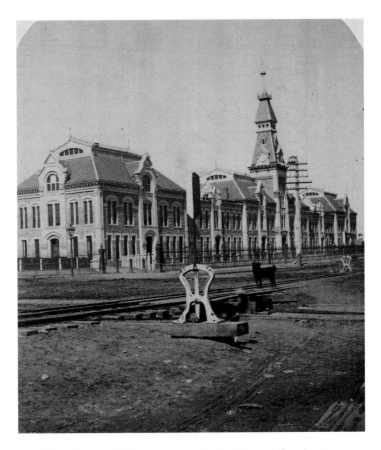

Alex Martin's circa 1882 cabinet card displays Denver's first depot, completed in the summer of 1881. The switch stand is clearly visible next to the dog. *Courtesy of Bill Eloe, Englewood, Colorado.*

Hotel, complete with fine furnishings ($400,000); and the Masonic Temple ($250,000), the depot's construction costs were significantly higher, reported as between $450,000 and $525,000.

A Leadville mine superintendent, headed to Chicago, purchased the first ticket from the newly opened depot.

THE SECOND STRUCTURE: 1894

A fire caused by wiring for the ladies' waiting room chandelier quickly spread to the second floor at the southwest end of the depot. Although the

electrical spark was the initial cause of the March 18, 1894 fire, there were many other contributors to the total damage. Flames spread quickly as the conflagration ran along the electrical wiring that filled the garret (attic/loft space under the roof) running the entire length of the depot.

Baggage and express men quickly moved luggage, over eight hundred trunks, as well as mail and express baggage, out of the way. Railroad clerks tried to save records and office equipment, either by carrying the equipment to a safer place in the depot or, on the other extreme, recklessly tossing papers out the window. Flames could be seen burning through the tower framework. Lack of water pressure severely hampered the Denver Fire and Highland Hose No. 1 firefighters as they tried to put out the blaze. Flames weakened the framework and support for the 165-foot clock tower. The weight of the Castle Rock lava stone clock tower eventually caused it to fall through the second floor, crashing into the Rio Grande dispatcher's room below. The Barkalow brothers' barbershop and the dining and lunchrooms in one of the depot's wings were losses. Smoldering pies were found on the lunch counter, but the cash registers were salvageable.

The property damage, primarily in the southwest end of the structure and the second floor, was reported to be between $125,000 and $200,000.

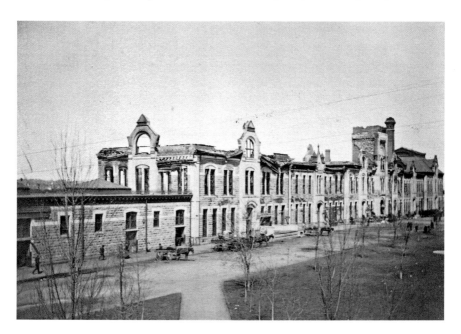

Gone are the roof and clock tower after the March 18, 1894 fire. *Western History Department, Denver Public Library.*

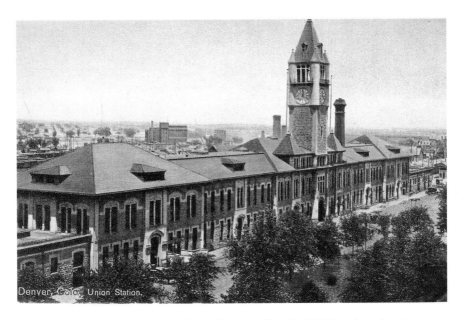

This postcard by Hugh C. Leighton Manufactures of Portland, Maine, shows just how grand the depot and park were. *Author's postcard collection.*

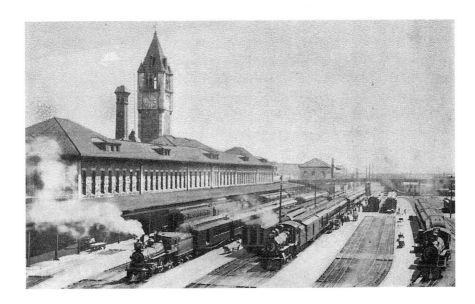

Clearly a busy day at the depot. *Author's postcard collection.*

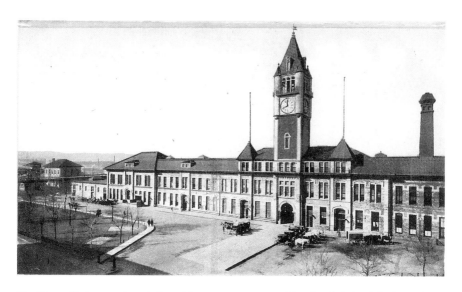

The Depot Park on a winter's day with express wagons waiting for their loads is the subject of this Colorado News Company postcard. *Author's postcard collection.*

Van Brunt and Howe of Kansas City were selected as the architects to rebuild the center section of the depot after the fire, reusing existing walls that were not damaged. The replacement tower was designed in the Romanesque style with a lower roofline for the wings. The central clock tower again would have four fourteen-foot-diameter clock faces for the public's viewing but was about forty feet taller than the previous tower. Construction was completed in about a year, and the building would remain in this form until it was demolished for the larger third structure.

BLIZZARDS

Denver's largest snowstorm to date came in the first five days of December 1913. During that early December snowstorm, 45.7 inches fell. Cleanup and snow removal took almost as many days. Snow was shoveled into horse-drawn wagons and dumped in Civic Center Park. On December 4 alone, Mother Nature dumped 63.0 inches on Georgetown, just west of Denver. This snowstorm closed down the depot, but not for as long as other businesses in the city. The snowstorm had a tremendous impact on the city's infrastructure as most roads were blocked by drifts.

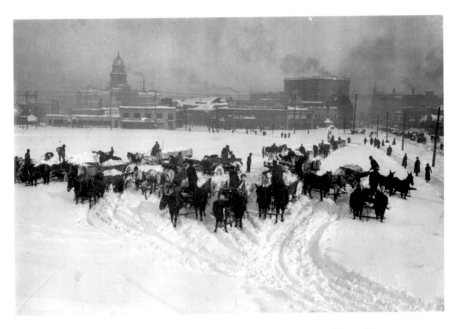

Civic Center Park provided open space to dispose of the excess snow, as horse-drawn wagons transported their loads from the city streets. *Western History Department, Denver Public Library.*

Headlines for the *Denver Post* on December 5, 1913, read, "Denver in Mantle of Shimmering White, Stops Activity and Everybody Jollifies."

The City Auditorium, jail and movie theaters all gave shelter to those who were stranded. As it was for the trains, the streetcars were halted. Anyone needing work could help the Tramway Company with snow removal for $3.50 per day.

RAIN AND MORE RAIN

As had happened before in Denver's early history, a heavy rainstorm on July 15, 1912, caused Cherry Creek to rise and begin flooding the city. Carts were used at the depot to move baggage, mail and express packages off the flooding floors. The basement flooded with as much as two feet of standing water. Train passengers waded through the muddy water to higher ground or were trapped at the depot until the water subsided.

The biggest flood happened twenty-one years later when, south of Denver, the Castlewood Dam broke, sending a wall of water into downtown Denver.

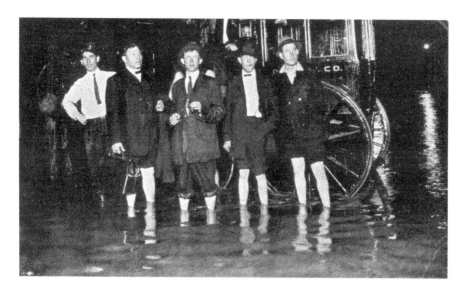

This July 24, 1912 postcard reads, "We had nearly two feet of water in our basement. There was a great deal of damage." *Author's postcard collection.*

Water flowed into the station's large waiting and baggage rooms, filling the passenger and baggage subway system and basement areas. The high-water mark in the basement of Union Station was six feet. Although with pumping equipment the employees were able to clean up and reopen rather quickly, the station's damages exceeded $14,000.

THE THIRD STRUCTURE: 1914

Soon, the increased population and travelers outgrew the 1894 structure and rail yards. By 1912, Denver needed a bigger station with expanded passenger platforms and baggage subways and a larger waiting room. Several plans for a larger depot were offered for consideration, including relocating and building in the vicinity of Eighteenth or Nineteenth and Larimer Streets or near Colfax, Champa and Speer Streets. Costs prohibited such relocations. The least expensive proposal was to work with the original building at its current location.

Denver hired Gove and Walsh to design the third and final center portion of the depot. Aaron Gove and Thomas Walsh were the designers of many warehouses and commercial buildings in Lower Downtown (LoDo), such

as Morey Mercantile Warehouse on Sixteenth Street, Littleton Creamery, Beatrice Warehouse, J.S. Brown Mercantile building on Eighteenth Street and the Edward Wynkoop Building/Spice Warehouse.

Popular from 1893 to 1915, the current design of the depot is considered Beaux-Arts Classic, the same style as the New York Grand Central Terminal. The style is made up of symmetrical coupled columns with baroque details. Architect J. Jacque Benedict, the first architect to be trained in Beaux-Arts, designed many fine Denver homes in this style.

Demolition of the old central portion began in September 1914. Passengers were redirected through the station, and railroad offices were relocated to the wings while the twenty-year-old stone clock tower (post-fire) was dismantled.

Granite obtained from Argyle Quarry, near Foxton, in South Platte Canyon was used.

Foundation walls and steel erection began before the year's end. In early January 1915, the old center section was completely excavated, allowing the first floor, 475 cubic yards of concrete, to be poured. The exterior terra-cotta walls reached third-story height two months later.

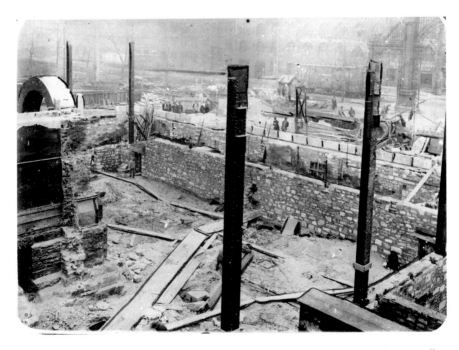

Construction progress on the third center structure, including metal beams and stone walls, is shown in this January 4, 1915 photo. *Western History Department, Denver Public Library.*

UNION STATION IN DENVER

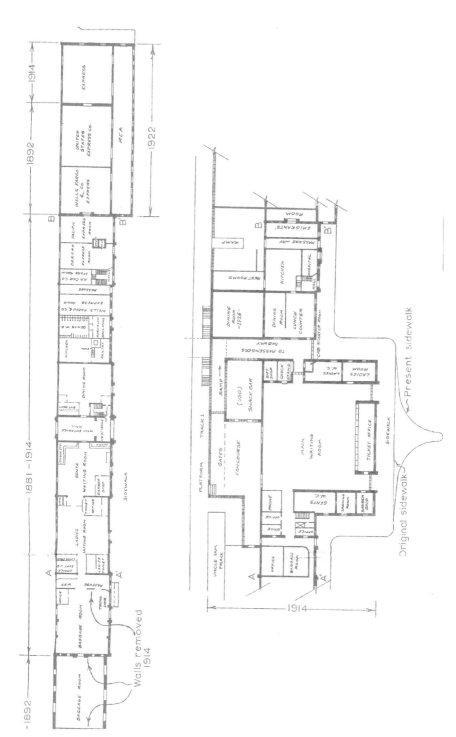

Gove and Walsh architectural rendering of the new 1912–14 center section, the third "face" of Union Station. *Author's collection.*

THREE STRUCTURES

Interior scaffolding was erected in April to allow lathing and plastering of the main waiting room. By May, marble floors had been completed for the restrooms and barbershop. After the roof was completed in early June, the main waiting room plastering began. Belgium black marble was the chosen stone for the ticket counter, trimmed in Yule marble. The American Fixture Company furnished and installed the main waiting room seats.

On April 1, 1915, the Denver Union Terminal Railway took over the station from the former owner, the Union Depot Railway Company.

All the while, new track was being laid in the yard. The new tracks were connected to the existing main track, and the entire roof of the center section had been completed by June 1915.

The public was able to use the new waiting room by Halloween 1915, but work continued on the express and baggage subways and remodeling of the baggage room. By December, over thirty thousand feet (fourteen thousand ties and 761 gross tons of CF&I rail) of track had been laid, and both the new express and baggage subways, lined with white enameled brick, were in operation.

General contractor Stocker & Fraser, along with other subcontractors, built the 1914 center section. Labor, material and furnishings for the new center section exceeded $3.8 million. From September 1914 until January 1915, the old center section was completely excavated, approximately eighty-five feet from the roof to the bottom of the footing, with some material recycled and reused for the new ninety-seven-foot expansion of the express rooms on the east wing. Each floor of terra-cotta walls took one month to erect, using over nine hundred tons from the Terra Cotta Company.

The new center section was constructed with terra-cotta that was textured and colored to look like granite. Granite from near Dome Rock was quarried for the front face, while stone from Fort Collins was used for the back-track side of the station. Lyons provided the red sandstone.

Although the exterior sides of the new station followed the pattern of the trackside and front entrance, only the rear and front clock faces were used.

The original 1880 wings with their 1894 lower roofline flank either side of the new central section. The interior clocks, at opposite ends of the waiting area, were bordered by marble slabs with adjacent plaster scrolls. A master control system was designed to synchronize the interior clocks to ensure that passengers would not miss their train departures.

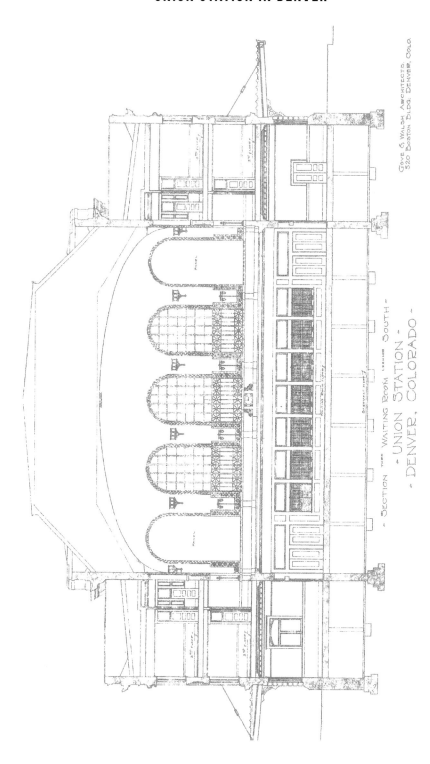

Interior layout of the third and final center structure to be built. *Author's collection.*

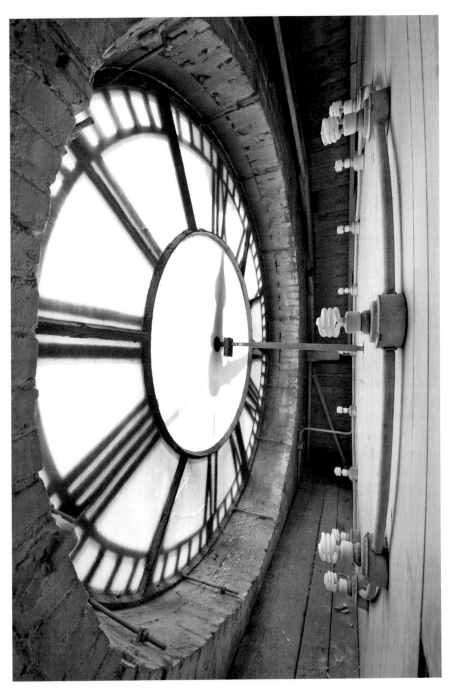

A rare opportunity to get a glimpse of the interior view of the exterior clock face. *Courtesy of Ellen Jaskol Photography.*

The Sixteenth Street viaduct had to be rebuilt to allow trains to pass beneath it, with subways for the passengers, mail, express and baggage underneath it all.

The new look of the station warranted a new name, so the new owners renamed the terminal Union Station, as we fondly refer to this grand historic landmark today.

THE INTERIOR

Once the new waiting room was completed, the Denver Terminal Company officers wanted to beautify the blank interior walls. A mural not only would add beauty to the bare seven panels but could also display the history of the West. It was decided that no one knew more about the early West than Denver's premier artist, Allen Tupper True, who had previously spent six months painting murals for the Panama-Pacific International Exposition in San Francisco.

The *Denver Post* reported on November 28, 1915, "Paintings depict the history of the West, telling the story of the winning of an empire by the intrepid pioneers who trekked across the plains more than a century ago."

In keeping with the theme of the train station, it was decided that the decorative mural should display the history of transportation and its influence in developing the West. The *Denver Post* went on to state:

> *In 1865, 4,480 conestoga wagons left Atkinson, Kan., to haul supplies to Colorado, Utah and Wyoming. With these wagons were 5,616 drivers and to haul them 29,720 oxen and 7,310 mules were used. These vehicles transported 27,000 tons of freight to what was then known as the "Utah country." It was not unusual for one of the conestoga wagons to be loaded with twenty tons of weight...*
>
> *And it is doubtful if many of today can visualize, even dimly, the great Western movement of the late fifties and early sixties, the achievements of the hardy men who were led to the Rockies by the lure of gold, the life they led, the obstacles they overcame, the conditions they found.*

However, either True was not available or there were inadequate funds because the main waiting room panels and walls remained bare.

THREE STRUCTURES

TUNNELS AND SUBWAYS

The *Denver Times* reported on June 15, 1916, that the new subway was complete:

> *The new subway at Union station, which hereafter will be used by all train passengers entering and leaving Denver, is now completed and will be open to the public tomorrow morning.*
>
> *It will officially be opened by the Denver Knights Templar when they embark on a special train of thirteen cars at 8:30 o'clock for their trip to the conclave at Los Angeles.*
>
> *The subway is considered a remarkable piece of engineering work on account of the conditions under which it has been constructed. It was built across the Depot terminals while more than one hundred fifty trains daily were passing thru the yards where the men were at work, without a single serious accident or without interrupting traffic for as much as five minutes. Work on it has been under way for more than a year. The surface of the tracks was elevated from five to six feet while the work was in progress.*

Tunnels under Denver streets were common in the city's early history. For many decades, the Public Service Company and the Denver Water Board found evidence of tunnels throughout downtown Denver as they excavated the streets for repairs and new steam or water lines.

The Windsor Hotel was connected to its Bath House and stables by a tunnel. Another tunnel connected the Windsor Hotel to the Omnibus & Cab Company and to the Barclay Hotel across the street.

Oral tradition says the Navarre was connected to the Brown Palace by a tunnel under Tremont Place for more risqué forms of entertainment. The capitol building is linked under Sherman Street to a state office building across the street by the original steam tunnel, which also carried sewage at one point.

Although there is no absolute proof, it is believed that the original depot was connected by a tunnel that could be reached from two different locations within the depot. Speculation is that one tunnel entrance in the depot was at the end of the passageway, at the bottom of the stairway next to the restaurant, and the second started down the stairs next to the west walk, went along the passageway to a large anteroom and from there continued on to the Windsor Hotel, located at Eighteenth and Larimer Streets. Most likely, there were other tunnels connecting to nearby hotels, such as the Oxford and Grand Central, that would enable train passengers to get to

TUNNEL DIAGRAM FROM UNION DEPOT

Denver loves the myths, legends, stories and mysteries surrounding its "infamous" downtown tunnels. *Courtesy of Jessie Howard.*

their destinations without wading through unpaved streets that were often muddy from rain or snowfall.

During the 1912–14 reconstruction of the center section of the depot, the anteroom, also known as a vestibule serving as an entryway into a larger one, which served as a waiting room, was bricked up, putting an absolute end to any possible tunnel.

"The most conclusive evidence to date" was reported by the *Rocky Mountain News* on October 27, 1990, after excavators drilled down fifteen feet under the Union Station parking lot and found Buffalo brick, used in the late 1800s. The Colorado Highway Department's chief geologist believed the evidence appeared to be the remains of a collapsed tunnel wall that connected Union Station to the Oxford Hotel and other lower downtown hotels.

Timing Is Everything

Accurate time is an absolute for the railroads. Employees of the railroad, as well as the general public, counted on the Union Station clocks to provide the accurate time. To know exactly which trains were on which tracks and avoid collision, the engineer and conductor set their watches by the station's clocks, all

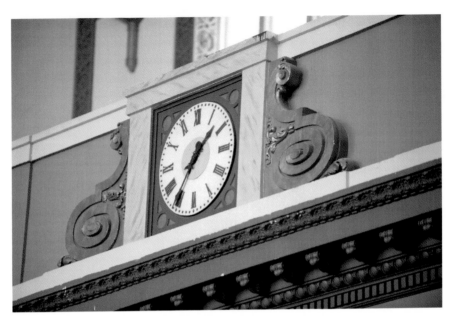

The interior clocks still flank both entrances to the grand hall of today's remodeled Union Station just as they did on opening day in 1914. *Courtesy of Ellen Jaskol Photography.*

of which were controlled by the master clock, manufactured by the Cincinnati Time Recorder Company. An electrical impulse from Western Union set the master clock from 1914, when it was installed, until 1971. The master clock, located in the basement, controlled the two large clocks at opposite ends of the waiting room, the rear- and front-facing clocks in the exterior arches of the station, one on the concourse and another clock in the stationmaster's office. From 1972 until 1978, time stood still because the clocks stopped working and funds were not available to fix them. In the summer of 1978, thanks to funds raised by the National Railway Historical Society and a retired railroad signal supervisor, W.C. "Chet" Hunt, new mechanical and electrical parts were ordered from the original equipment manufacturer and installed. Once again, precise railroad time could be viewed from both outside and inside the station.

No Kissing

Everyone knows the trains must depart on time, so in the summer of 1902, the railroad officials in Pennsylvania decreed that loved ones had to kiss

goodbye before they reached the train so they wouldn't delay its departure. Denver's depot authorities followed through, but not with much success. The crowded depot was typically full of those waiting to see someone they had not seen in years or who had traveled long distances to visit loved ones, making it difficult to patrol.

Spitting was also frowned on, unless one used the spittoons provided throughout the depot as late as the 1930s.

EXPRESS FREIGHT, MAIL AND LOTS OF BAGGAGE

By the end of 1914, the depot had to add an annex to handle all of the express business. There were as many as nine express freight companies that operated out of the terminal annex until the 1930s. In 1857, John Butterfield and Ben Holliday formed the Overland Mail Company, a rival to William Fargo and Henry Wells's American Express Company back east. The Overland Mail Company dominated the western stagecoach and banking business. The Treaty of Omaha of October 1869 allowed the express companies to use trains rather than stagecoaches. Other express companies that started on the East Coast and expanded to the West Coast were the Adams Express Company, Globe Express, United States Express Company, American Express and two owned by the railroads Union Pacific Express and Denver and Rio Grande Express. A decade later, the American Railway Express Company, a 1918 consolidation of Wells Fargo, American, Adams and others, became known as the Railway Express Agency, Inc. (REA).

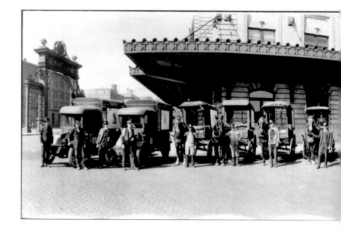

The American Railway Express Agency's office was on the far side of the west wing. Proud drivers pose for this 1917 photograph outside Union Station. *Western History Department, Denver Public Library.*

THREE STRUCTURES

Back east, as early as 1832, the Post Office Department acknowledged the value of transporting mail by train. By 1838, all railroads had designated post routes for mail service. Until 1864, mail was sorted by the post office;

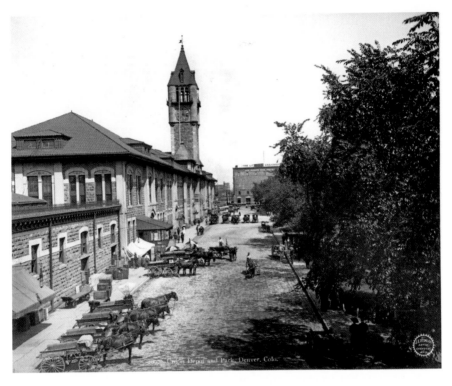

Express wagons lined up ready to be loaded with goods. The Littleton Creamery is in view just down the tree-lined street of Wynkoop. *Courtesy of Wyoming State Museum and Colorado Railroad Museum, Golden, Colorado.*

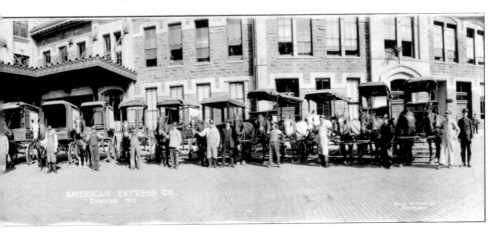

UNION STATION IN DENVER

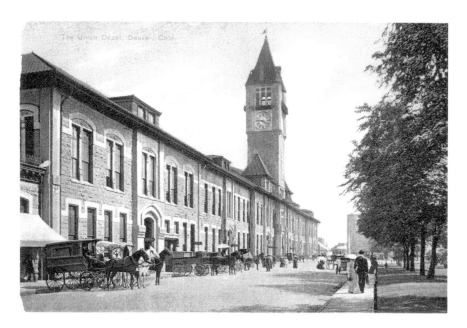

Postmarked September 14, 1908, Thayer's postcard proudly displays the Depot Park and horse-drawn express wagons. *Author's postcard collection.*

then the first U.S. Railroad Post Office route was officially established on the Chicago & North Western Railroad. Mail clerks not only had to handle and sort mail quickly as the trains moved from town to town, but they also had to deal with other items—such as live chicks—being transported.

While a one-horse buggy could handle the mail coming in and out of Denver in the early 1880s, it was not adequate as the population and quantity of mail soared. Mail came in by trains and was off-loaded and transferred to the main downtown post office by transfer companies like the Denver Omnibus & Cab Company. The first register station, created inside the depot in 1902, provided security for the mail until it was transferred.

Depot parcel post stations were established after passage of the 1913 Parcel Post Law. By 1922, the post office and Union Station had signed an agreement whereby the terminal would sort mail bags for delivery by trains and trucks, and the parcel post station would sort the city's parcels. The transfer clerk's office and Railway Mail Services were located on the mezzanine.

In the spring of 1901, the depot mailroom gained an unusual "guard" for the mail when a stray part bulldog, part shepherd wandered in. The mailroom employees noticed this dog seemed to have a keen scent only for

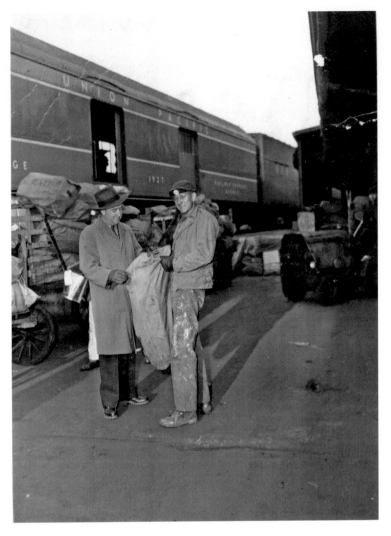

Loading mailbags on the Union Pacific train. *Colorado History Center, Stephen Hart Library, Denver Rio Grande Photo.*

mail pouches; Jim, as they called him, took little or no interest in other bags or parcels. However, the dog watched every pouch being loaded on trucks or being offloaded on the platform with great interest.

The *Denver Times* reported on March 11, 1901:

> *An agent of a New Jersey manufacture of electric motor vehicles is expecting to receive an order from the Denver Union Depot and Railroad company*

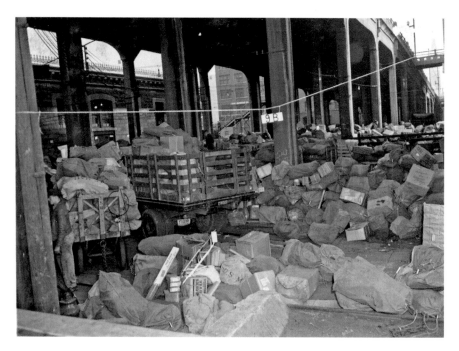

Christmas 1947 mail and packages being sorted under the Sixteenth Street viaduct at Union Station. *Colorado History Center, Stephen Hart Library, Denver Rio Grande Photo.*

for the latest thing out in the way of auto-vehicles, auto-trucks for handling baggage and express on the platforms of the station.

The Christmas rush of 1947 overwhelmed the mailroom at Union Station to the point where a temporary sorting area was established under the Sixteenth Street viaduct to handle the overflow. That season, mail rail cars were filled to capacity.

The government built a Terminal Annex for the Denver Post Office in 1959 on the other side of the Sixteenth Street viaduct adjacent to Union Station. Architect Temple Buell designed the more than $7 million building, which opened in April of that year.

Over sixty different trucks or wagons handled all the mail and parcel routes; the mail was sorted into bags by the Denver Mail Department until 1967, when airmail and mail trucks replaced the trains in transporting parcels and mail.

At the turn of the century, the depot reported handling over 784,000 pieces of baggage for those coming and leaving.

The railroad also transported something much more valuable than parcels and mail. In the fall of 1934, the government decided to transfer several

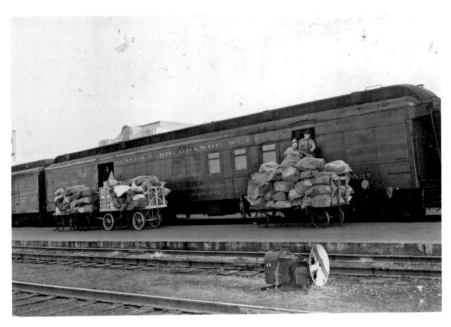

A Denver and Rio Grande train car unloads onto carts for distribution at Union Station, December 1947. *Colorado History Center, Stephen Hart Library, Denver Rio Grande Photo.*

Mail piled to the awning at Union Station. Littleton Creamery can be seen on the far right of this 1947 photograph. *Colorado History Center, Stephen Hart Library, Denver Rio Grande Photo.*

billion dollars' worth of gold bullion from San Francisco to Denver's Mint. The gold was transported in seventy-five railroad mail cars as parcel post, divided among twenty-five trains. Once the gold arrived at Union Station, it was off-loaded, transferred into mail trucks and escorted by police cars on its short journey to the Mint.

Chapter 3

RED CAPPERS AND OTHER RAILROAD EMPLOYEES

The railroads employed many different ethnic groups, most notably Italians, Irish, Chinese and African Americans. Immigrants provided much of the needed labor for the construction of the railroads, making anywhere from $45 to $125 a month in 1885, depending on their skills. Master mechanics and train engineers were the highest-paid employees.

A Riverside Cemetery headstone reads, "Tadaatsu Matsudaira, younger brother of the last Governor of UEDA Province, Japan, first Japanese resident of Colorado." This civil engineer was an employee with the Union Pacific Railroad during his short-lived thirty-three years.

Chin Lin Sou, who arrived in America by ship in 1857, became a Central Pacific Railroad employee. The Union Pacific railroad hired Chinese laborers to improve its tracks by smoothing the grades and reinforcing the rails because the energetic Chinese laid better tracks than the American laborers. When the Denver Pacific Railroad was organized to construct a spur from Denver to Cheyenne, it hired Chin Lin Sou as foreman for its Chinese laborers. After his railroad career, Sou supervised miners in Gregory Gulch. The Chinese were allowed to extract whatever gold they could, primarily from abandoned mines. Sou made enough money to move his family to downtown Denver and open a store in "Hop Alley." At the turn of the century, there were over three thousand Chinese in Denver. Sou organized the Chinese Trading and Insurance Company in the early 1880s and was a leader in the Chinese community. He remained in Denver with

his family until his death in 1894. Today, the capitol building's north wing displays his portrait to honor this Colorado minority pioneer.

The railroad workers had their own lingo, using terms such as "red caps/cappers," "air-monkey," "brass collar," "grass wagon" and "grazing ticket," to name a few. Red caps carried the baggage to and from the trains, the color of their caps distinguishing them from other uniformed railroad men.

Just after the Civil War, George Pullman, a cabinetmaker by trade and owner of the Pullman Palace Car Company, built comfortable sleeping cars, or "hotels on wheels." Pullman distinguished his train cars from those of his competition by giving the American middle class an opportunity to experience first-class service by uniformed porters. Pullman sleeping cars eliminated the necessity to try to sleep sitting up. Like hotel rooms on wheels, the Pullman sleeping cars were complete with electric lights and bathrooms and decorated with carpeting and brass fixtures to give the feel of luxury. Demand for this sleeping car increased when a Pullman car was used on the funeral train carrying President Abraham Lincoln's body.

The dining cars served good food and wine, like fine-dining restaurants. Dining car tables were set with white tablecloths, cloth napkins, real

Who wouldn't want a bottle of French champagne to go with their twenty-five-cent caviar for lunch? Local Denver Zang beers were another option. *Western History Department, Denver Public Library.*

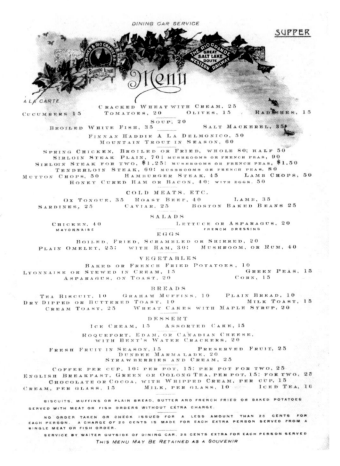

Few remain who can remember the days of ten-cent coffees. *Western History Department, Denver Public Library.*

silverware, durable china and vases of fresh flowers. Freshly baked pies were made from scratch and served on board. Mountain trout could be ordered from the Colorado train car menus.

Union Pacific's luncheon special on April 22, 1916, offered canapé of anchovies, cream of asparagus, a cup of consommé and cucumbers or head lettuce for twenty-five cents each. Baked pork and beans with home-style brown bread would set you back thirty cents; a hamburger steak, forty-five cents; special farm sausage and mashed potatoes, fifty cents; and a half "young" fried chicken with a corn fritter, sixty-five cents.

"Popular Priced Coach Meals, Served in Coach, Chair and Tourist Cars" could be ordered in 1935 on a Union Pacific dining car. Twenty-five cents

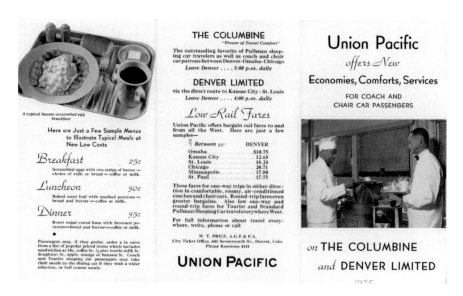

Union Pacific's 1935 Columbine train menu, served by black dining car porters. *Western History Department, Denver Public Library.*

would purchase bacon, scrambled eggs, rolls, butter, coffee and milk for breakfast, but if you couldn't afford that option, a nickel would get you any one of these items on the à la carte menu: a boiled egg, a doughnut, fresh fruit, coffee, milk or, if you preferred your dairy in a more frozen form, an ice cream cone.

Pullman hired and trained blacks as porters for his sleeping cars. Porters not only provided first-class service day and night, but they also carried baggage, shined shoes, fluffed pillows, made up berths and, often, sat as night guards at the back of the cars in addition to serving passengers food and drinks—all at any time, at the beck and call of an electric bell. They also cleaned the sleeping cars, all for a small salary plus tips. Black employees, who managed the provisions and attended to the passengers on board, were given permission to take home leftovers—an added bonus to their pay.

The Pullman Company employed more blacks than any other United States company by the 1920s. Although the wages may not have been the best, a position with the railroad gave small-town blacks the opportunity to travel to big cities and was one of the best jobs available to them. It provided them with an opportunity to join middle-class America, to purchase homes and dress clothes. Many railroads hired blacks as cooks, waiters and red caps. Black women were hired as Pullman maids to assist female passengers with their baths and to provide manicures and assistance with the children.

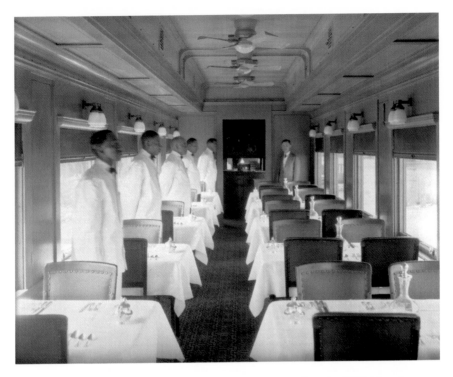

Uniformed porters for D&RGW waiting to serve their guests aboard a 1927 thirty-six-seat dining car. *Western History Department, Denver Public Library.*

As hosts, porters greeted the passengers as they boarded. They were expected to smile and be humble, regardless of the treatment they received from any passenger. The Pullman Company hired "spotters" to work like spies, ride the rails and report any infractions of the porters, whether it be their behavior or lack of tidiness. Drinking and smoking on the job were strictly forbidden.

Although Philip Randolph organized the first all-black union, the Brotherhood of Sleeping Car Porters, in August 1925, it would be years before fair labor laws were passed and support came from white unions. In a 1929 survey of Denver's African American population, 325 blacks were members of the Trade Unions in Denver, and 125 belonged to the Brotherhood of Sleeping Car Porters.

The Union Pacific superintendent posted the need for three men to work trains out of Denver in 1937. Freddie Gomez of Denver took the job and quickly mastered the ability to pour hot coffee and tea into china cups on a moving train without spilling a drop. He was chosen to work special trains, carrying very important people, as a waiter and bartender. Besides railroad

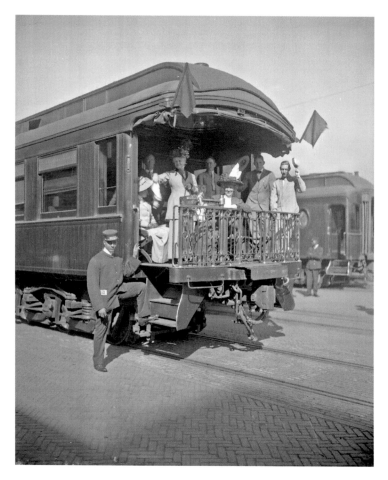

A porter and travelers at the rear platform of the D&RG Pullman observation sleeper railcar in June 1910, Union Station. *Western History Department, Denver Public Library.*

presidents and Mr. and Mrs. Harry S. Truman, he also served troops headed to war. For years, he served Omaha steaks and stiff drinks on the Union Pacific routes between Chicago and the West Coast for a little over sixty dollars a month, which was enough to buy a little house in Five Points.

One African American, Elijah McCoy, with a mechanical engineering background, took a job with the Michigan Central Railroad as a locomotive fireman and oiler. The responsibilities of such a fireman were to fuel the steam engine and use an oiler to lubricate the train's axles and bearings to keep it from overheating. McCoy developed a lubricating cup that used steam pressure to pump oil through a small bore tube to the bearings without

the train having to stop. This invention was one of over fifty devices McCoy received patents for during his lifetime. Although others would try to invent different versions of oilers, Elijah McCoy's oil-drip invention was asked for specifically by railroad engineers and machinists. They wanted "the real McCoy" because it was superior to all other oilers.

A Five Points resident, Harvey Pipkin, worked as a dining car waiter for the Union Pacific after World War II. Like Pitkin's family, many blacks migrated to Denver, specifically to the nearby Five Points neighborhood, to work for the railroad. These railroad men supported other black-owned businesses in the neighborhood.

Many African Americans during the years between 1900 and 1920 migrated from the South to the Midwest looking for employment and relief from the Jim Crow South. One of those individuals was Jesse Howard's maternal grandfather, George Dickerson, who was born in Independence, Missouri. George migrated to Colorado looking for a better life and found employment with Union Pacific Railroad in Denver. George's job was to clean the dining and sleeping cars at the depot and switching yards near downtown, by Fortieth Avenue and Gilpin Street. After establishing employment, George was able to marry Essie Morgan, who migrated to Denver from the cotton fields of Texas. Together they raised a family in the Five Points area near Twentieth and Ogden Streets and attended Central Baptist Church until George's death in 1958. George and Essie Dickerson's descendants represent seven generations of native Denverites.

In 1938, Local 465 opened an all-black union club in Five Points: the Fraternal Club of Diner-Car Waiters and Porters. Over two hundred members of well-dressed railroad men and ladies belonged and enjoyed entertainment among their peers since they were not welcomed in the white establishments in Denver. The railroad men were the most respected members of their communities. Many successful blacks started their careers with the railroad or were raised by fathers who rode the rails and served the passengers.

Prior to being executive secretary and executive director of the National Association for the Advancement of Colored People (NAACP), Roy Wilkins, civil rights activist, was a dining car waiter.

The first black accepted as a member of the American Institute of Architects, Le Roy Hilliard, paid tuition at Armour Institute on Chicago's south side from his dining car waiter wages.

California Supreme Court justice Wiley W. Manuel's father was a Southern Pacific dining car waiter. Hastings College Law graduate Wiley Manuel was the first black to serve on the high court in California.

During President Jimmy Carter's administration, Patricia Roberts Harris served as secretary of housing and urban development. She was the first black American United Nations delegate. President L.B. Johnson appointed her ambassador of Luxembourg. Patricia Roberts Harris was the first African American to be an ambassador and the first to serve in the United States Cabinet. Patricia was the daughter of a Pullman car waiter.

Wellington E. Webb Jr., Denver's first African American mayor, who served three terms, was the son of a porter. During Webb's twelve-year tenure, the Colorado Convention Center and Denver International Airport were completed, former Stapleton Airport was redeveloped, the Denver Art Museum was expanded, the Central Platte Valley redevelopment began and the new city office building was completed and named in his honor. Possibly his biggest accomplishment was the completion of an African American research facility, the Blair-Caldwell Library, built in Five Points on lots where porters for the railroad once lived. As a young man, after his parents divorced, Wellington spent fond summers with his dad riding the Chicago & North Western Railroad, while his dad served drinks in the bar car and announced stops along the route. Wellington Webb Sr., originally from Birmingham, Alabama, worked for the railroad for forty-two years.

The Irish, although unwelcomed by most American employers, were able to gain employment on the Transcontinental Railroad or in the mines. Denver city auditor Dennis Gallagher's grandfather William was one of many Irish immigrants to work for the railroad in Denver. William began as a locomotive fireman, also known as an "ash cat" or "bake head," but worked his way up to the responsibility of operating the locomotive as engineer, a position an African American could never dream of holding.

By 1940, there were some fifty red caps working at Union Station. Prior to the railroad labor act and the interstate commerce commission decision that year, red caps worked for tips only. After the labor act went into effect, any traveler wishing to have his or her bags carried had a ticket attached to the bags. The red capper would receive a flat rate of ten cents per bag plus whatever tip the traveler chose to give. Red caps were required to turn in the ticket stubs and the ten cents for each bag at the end of each day. The red capper was paid thirty cents an hour and eight and a half cents per stub, in addition to whatever tips he received. The new plan meant that not only was the red capper a true salaried employee, but it also demonstrated to the public that he was part of a trade that required skills, such as knowing the train schedules and getting the right number of bags to the correct place or person.

WELCOME TO DENVER

THE CITY'S GATEWAY

Mayor Robert Speer loved lights and the monuments and structures that made Denver beautiful. Train passengers stepping outside the doors of the depot were greeted by a beautiful seventy-ton bronze-plated metal arch, illuminated with over one thousand light bulbs that read, "Welcome." Speer dedicated the sixty-five-foot-high arch, designed by the Denver Art Association, on July 4, 1906, in front of a crowd of thousands. The cost of this metal arch was shared by the water, power and telephone companies; Colorado Fuel & Iron; and the Elks Lodge, as well as the Depot Company and the railroads.

Within a couple years, the chamber of commerce realized that those leaving Denver were also passing through the Welcome Arch, so they changed the return side to say, "Mizpah," a Hebrew salutation from Genesis, a watch post with the meaning that the Lord should look over us while we are apart from one another.

Many celebrities, entertainers, politicians and even royalty were greeted by the Welcome Arch. In 1908, Denver hosted the National Democratic Convention, giving many out-of-town visitors, as well as the presidential candidate, the opportunity to see the arch.

Besides Mayor Speer, another admirer of lights, Thomas Edison, passed through the arch on his September 1908 trip to see the illuminated theater district on Curtis Street.

One year later, newly elected twenty-seventh president William Howard Taft made his first trip to Denver. While in the city, he visited the Denver Press Club and was entertained by the Mr. and Mrs. Thomas F. Walsh family at

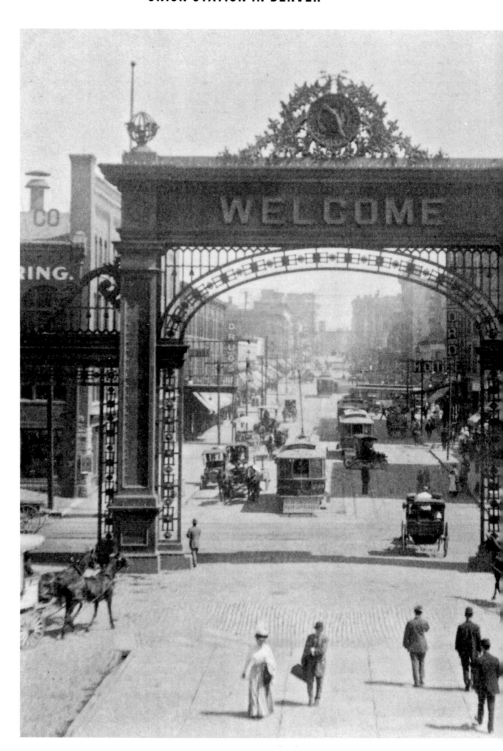

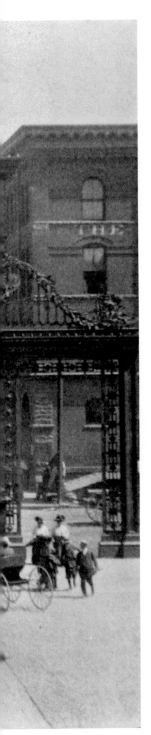

the Wolhurst Estate (Littleton, Colorado). Thomas Walsh of Ireland made his fortune in the San Juan Mountains, specifically at the Camp Bird mine. Walsh and President Taft were considered close friends.

President Theodore Roosevelt's presidential special train arrived in the Rio Grande rail yards in 1905. Teddy Roosevelt was one of five presidents to eat at the Buckhorn Exchange, which opened in 1893, the year of the silver crash, also home to Denver's first liquor license after Prohibition in 1933. In addition to presidents, politicians and gamblers, the Buckhorn Exchange fed and entertained businessmen, barons, railroaders and chiefs from the Sioux and Blackfoot tribes. Although Theodore Roosevelt was born into a New York City high-society family, bear hunting on horseback in Colorado was his idea of a vacation. In April 1905, he killed his first bear in the Glenwood Springs area.

The next time Denver saw Theodore Roosevelt was in August 1910. He was again on horseback, but this time riding the downtown streets with the Rough Riders. The Rough Riders, primarily cowboys, ranchers and outdoorsmen, were veteran members of the First U.S. Volunteer Cavalry. They volunteered at the request of President William McKinley and later fought, during the Spanish-American War, under the command of Lieutenant Colonel Theodore Roosevelt.

President Taft returned in October 1911 to address the Public Lands Convention at the City Auditorium. Another speech at the auditorium, this time in support of the League of Nations, was given by President Woodrow Wilson during his September 1919 visit. Woodrow Wilson was the last president to ride in a horse-drawn carriage to his inauguration and was the only president to earn his doctorate degree.

World War I hero General John J. "Black Jack" Pershing visited wounded soldiers in January 1920 at the Army General Hospital, later known as Fitzsimons.

Underwood & Underwood captured the Welcome Arch and street traffic of Seventeenth and Wynkoop Streets in this post-1906 stereo card. *Western History Department, Denver Public Library.*

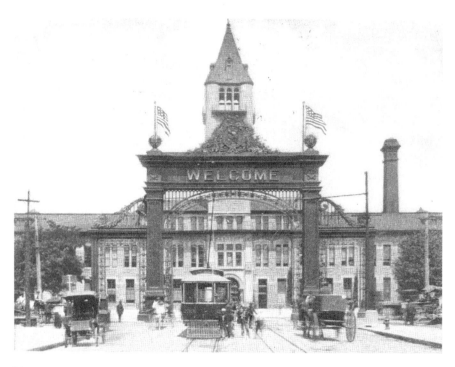

This October 1907 postcard reads, "Had to go down to the depot this morning to sign my ticket at 7:30 A.M." *Author's postcard collection.*

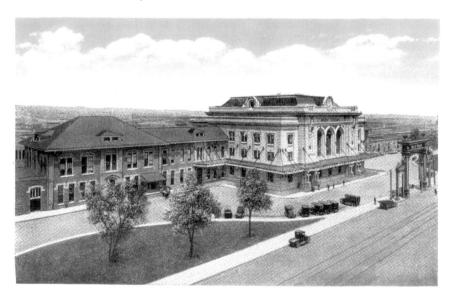

Denver's Sanborn souvenir postcards were published starting in 1920. The description on the back says that the New Union Depot "handles an immense passenger traffic." *Author's postcard collection.*

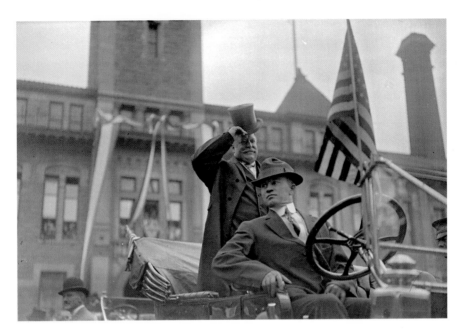

In this circa 1908–09 photo, President William Howard Taft tips his hat to the Denver crowd in front of the depot. *Western History Department, Denver Public Library.*

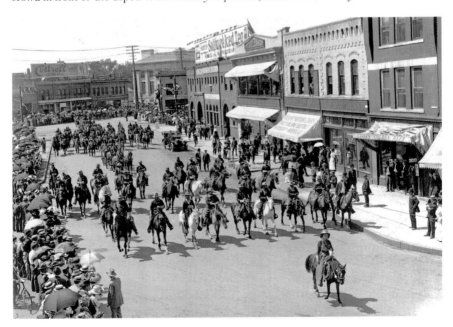

President Theodore "Teddy" Roosevelt with the Rough Riders parading down Broadway in downtown Denver, August 29, 1910. *Western History Department, Denver Public Library.*

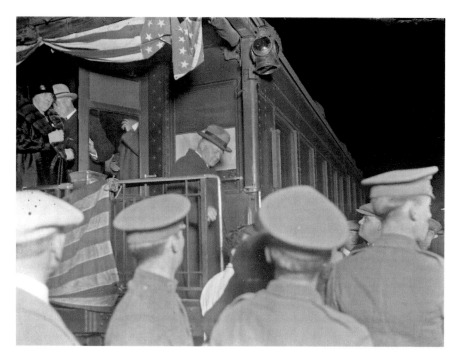

Harry Rhoads, photographer, captures President Henry Herbert Hoover as he arrives by train at Union Station. *Western History Department, Denver Public Library.*

Another speech was given at Fitzsimons in June 1923 by our twenty-ninth president, Warren G. Harding, just months before his death. The president would have one last train ride when his funeral train went through Cheyenne in August 1923, on its way back to his home state of Ohio.

Henry Herbert Hoover, traveling with his wife, Margaret, stopped in Denver on November 6, 1928, on his way to the West Coast during his presidential campaign tour. Hoover gave his speech from a platform erected in front of Union Station. This was his second time to visit Denver; he had been in the city some thirty-six years earlier as a young engineer.

Another presidential candidate, New York governor Franklin Delano Roosevelt, visited Denver in 1932. After being elected the thirty-second president, FDR rode the train again to Denver.

One of the most famous people who passed through the Welcome Arch at the train station was Marie of Romania. She was as popular abroad as she was in her own country. In the fall of 1926, the queen came to America to witness the dedication of the Maryhill Museum of Art in Washington but also to "see the country and meet the people." The queen desired to see Pikes Peak and

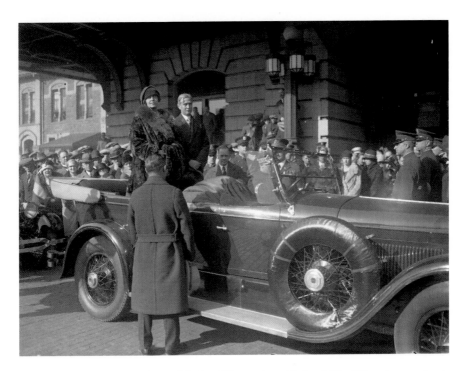

On November 10, 1926, Queen Marie of Romania, with Lord Ward Bannister, arrived at Union Station to be greeted by a large Denver crowd. *Western History Department, Denver Public Library.*

American Indians and wanted to ride a horse. Prince Nicholas, her son, and Princess Ileana, her daughter, traveled with her. The royal party, with over one hundred pieces of luggage and six personal attendants, plus press, traveled on a special B&O Railroad train dubbed the "Royal Rumanian," which stopped in numerous cities between both coast lines from New York to Seattle. On November 10, 1926, the queen was honored by the Mile High Club at a reception held at the Brown Palace Hotel.

Probably no one traveled to Denver by train more than William Fredrick "Buffalo Bill" Cody. Cody, who joined the Pony Express in 1860, scouted for the army after the Civil War and started entertaining the public with his shows in 1872, at the young age of twenty-six. During the 1859 gold rush, Cody visited Colorado Springs. He visited Colorado thirty-five times from 1859 until his death in 1917. He performed with five different attractions: Buffalo Bill's Combination Acting Troop; Wild West Show; Pawnee Bill's Far East; Sells-Floto Circus and Buffalo Bill's Wild West; and, lastly, the 101 Ranch Combined Show. In September 1898, Buffalo Bill and the Rough Riders of the World arrived by

train, filling over fifty rail cars of animals, gear, cast members and performers. It took nearly six hundred people to set up and produce a Wild West Show.

Dwight D. Eisenhower, as a child growing up in Texas, lived in a tiny house by the railroad tracks while his father cleaned train engines for a living. Dwight was appointed to the U.S. Military Academy at West Point in 1911 and quickly became a football star. Five years later, he married Mamie G. Doud of Denver. During his military career, Eisenhower reported to General John J. "Black Jack" Pershing in the late 1920s and commanded the troops that invaded France on D-Day in 1944. Eisenhower was elected our thirty-fourth president in the fall of 1952 and reelected again in November 1956. President Eisenhower's frequent visits to Denver, his wife's hometown, were by train until commercial airlines became the common mode of transportation. Eisenhower had dinner with Richard Nixon and Mr. Dulles at the Brown Palace Hotel during his August 1952 trip. A few years later, in September 1955, he had a heart attack while in the city and spent seven weeks in Fitzsimons Army Hospital before being released on Armistice Day, November 11.

Conventions brought many people by train to Denver. The Benevolent and Protective Order of the Elks (BPOE), Knight of Columbus and Shriners are just a few of the organizations that held conventions in the city.

Others who traveled by train and passed through the Welcome Arch include American actress Ethel Barrymore; Denver's "King of Jazz" Paul Whiteman; French actress Sarah Bernhardt; composer John Philip Sousa, who toured with his musical band for forty years; Cardinal Patrick Hayes (archbishop of New York); University of Notre Dame coach Knute Kenneth Rockne; actress Mary Pickford; Edward H. Harriman; baseball star Babe Ruth; British hunter and colonel in the British Indian army Jim Corbett; James Joseph "Gene" Tunney, who defeated Jack Dempsey twice; politician Charles Evans Hughes; chief justice of the U.S. Supreme Court, U.S. secretary of state and governor of New York Jack Dempsey and his wife, Estelle Taylor; and cowboy Will Rogers, vaudeville performer, humorist and motion picture actor.

The Welcome Arch was dismantled twenty-five years after it was erected. The monthly utility bill and maintenance for the lighting was expensive—$9,000 a year—and the arch caused congestion of cars trying to pass through the narrow opening while driving in and out of the station. It needed repairs that would cost in the thousands, and with the Depression of the 1930s, funds were tight. It was decided that the arch now blocked the view of the station, so on December 6, 1931, a junk firm removed it.

WEARY TRAVELERS

NEARBY LODGING

The railroads created a heightened demand for lodging. The Transcontinental Railway allowed businesspeople and travelers the opportunity to traverse three thousand miles coast to coast in a week, which was a great improvement from the nearly three long months it took by stagecoach. The trains allowed goods and people to be moved at greater speeds and with less expense.

Accommodations and transportation are linked. Railroad tracks could be laid in any direction, for the most part, and trains could run year round. People could travel anywhere they wanted, for business or pleasure, if they could afford the price of the ticket. Places for food and lodging near every terminal were essential. The railroads published promotional material and brochures to advertise not only the train routes, schedules and distances but also what travelers could expect in terms of hotels or other types of accommodations when they reached their destinations. It wasn't uncommon for people moving to a new city to become semipermanent hotel residents until they purchased their first houses.

Railroad companies required fuel and maintenance for the trains and food and shelter for the passengers, creating a demand for way stations along the routes. Generally, every one hundred miles along the track there were refueling stations (coal and water), as well as workshops for locomotive maintenance. Railroad officials, workshop engineers and maintenance crews all required food and shelter, offering incentive to the railroad companies to build hotels. Prior to sleeping cars on the

trains, the passengers also needed a place to eat and sleep during their long journeys.

Train passengers stopping in Denver, whether it was for one night or for an extended stay, had many hotel choices within blocks of Union Station. There were no fewer than nine hotels that lined Seventeenth Street from Union Station to Broadway in 1905.

Many hotels signed up with the different railroads to gain advertising opportunities or, in some cases, to offer multiple accommodations that they owned and operated along the railroad line, similar to chain motels of today. Hotel trade cards were placed on train seats and handed to passengers as they left the passenger cars, making it easier for them to choose where to stay for the night. Downtown hotels also hired "runners" to direct passengers to their hotel. Runners, often young men or boys, also helped haul the luggage for the soon-to-be hotel guests.

Railroad companies built convenient hotels along their routes. In Laramie, Wyoming, the Union Pacific built the Laramie Hotel, which could not only provide lodging but also published in its promotional guides that "one thousand persons can be comfortably accommodated at table."

Colonel David Child Dodge held the positions of the first general freight and ticket agent and, later, general manager of the Rio Grande Western and the Denver and Rio Grande Railroads. Dodge built the Shirley Hotel, which opened in January 1905 at Seventeenth and Lincoln Streets. A year after the Shirley Hotel opened, Colonel Dodge teamed with David Moffat and remained involved with the extension of the Moffat Railroad from Denver to Steamboat Springs until his death.

Besides the hotels built by the railroad companies or railroad-related investors, there were many types of hotels available to meet the different needs of the travelers. Denver's Brown Palace, completed in 1892, is a large, lavish first-class hotel for those seeking luxury. Although it is located at the opposite end of downtown from Union Station, in earlier years there were carriages, and in the later years, prior to the tramway, there were omnibuses waiting at the depot to take travelers to their hotel destination. The Brown was a favorite of presidents and presidents-elect. Since 1905, with the exception of our thirtieth president, Calvin Coolidge (1923–29), and Barack Obama, every visiting president has slept or eaten there. Dwight and Mamie Eisenhower probably stayed there more often than any of the others. During World War II, room 321 served as an officer's club, and the Tenth Mountain Division soldiers tried rappelling from the balconies. Since 1945, each January, the Brown entertains an unusual honored guest, one most likely not seen in any other

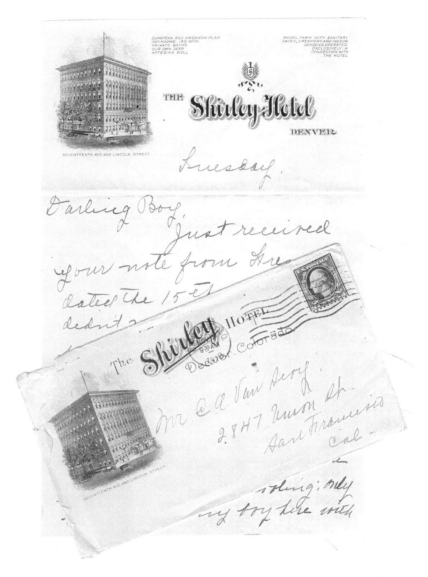

This 1918 letter mentions that "Denver is the best lighted city I've seen anywhere" and remarks on what wonderful improvements Mayor Speer made in the city. *Author's Historic Hotel Collection.*

hotel. While ladies enjoy their tea and scones a few feet away, the grand champion steer is displayed in the atrium lobby as part of a long-standing tradition during the last week of the National Western Stock Show.

A letter written by a son to his mother gives one a glimpse of what it was like arriving at the train depot in 1883:

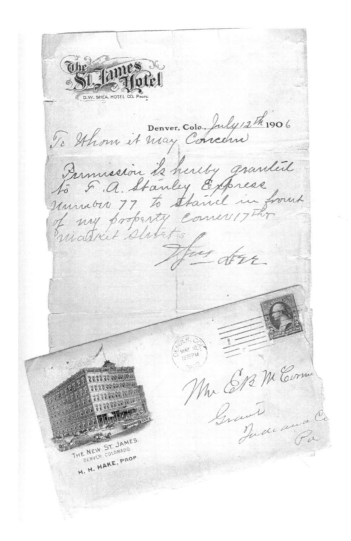

The St. James Hotel was located at 1528 Curtis Street. Previously known as the Wentworth, the St. James opened in the fall of 1881. *Author's Historic Hotel Collection.*

I saw Long's peak and Pike's peak before we got to Denver...I presume there were 25 carriages at the Depot and [the drivers] all yelling the best they could. Everyone asked me where I wanted to go. I finally told one fellow I wanted to go to the Saint James Hotel. He said he was a Saint James carriage so I got in. It was about ½ mile there. When I got out he said this will be 50cts if you please so I paid him. He wanted to call for me in the morning but as I had kept my eyes open I thought I [could] find the way. The reason

I put up at the St. James was I had seen a Denver paper with all the hotels advertised and this one had more guests than any of the rest.

Many years later, a souvenir book, compliments of the St. James Hotel's proprietors, described the hotel and its amenities:

THE ST. JAMES

The location of The St. James is the best in the city—on Curtis street, near Sixteenth street, and directly opposite the Tabor Grand Opera House. It is the Madison Square of Denver, and is within one block of the Post Office. A feature of this well-conducted house is its dining-room, not alone for its unsurpassed cuisine and service, but also for its score of well-disciplined colored waiters, under the direction of the veteran, Mr. A. Plummer, formerly of the Millard, Omaha, and the Hotel Ryan, St. Paul.

The St. James is home of the commercial traveler, mountains of whose trunks daily arrive and depart. So great has become its patronage of this needful adjunct to trade that some thirty rooms have been expressly provided and furnished for their convenience, all being large and well lighted. No better sample-rooms can be found in any hotel.

The Triennial Conclave of Knights Templar, which convenes in Denver in August next, has been farseeing enough to charter all available rooms at this favored hostelry.

ST. JAMES BARBER SHOP AND BATHS

Mr. Wm. Bucks became the proprietor of the above in March, 1892, and since that time, owing to courteous treatment, best workmanship and regular prices, the patronage has increased so rapidly that new chairs are being constantly added. Mr. Bucks himself is a skillful workman and thoroughly understands his business, having had over twelve years' experience here in Denver, where he is well and favorably known.

LAUNDRY.

The St. James has a very efficient laundry service. Garments delivered at the Hotel office in the morning being returned the same evening, beautifully and carefully finished. The finest machinery and best skill are employed in this laundry.

The American House and Planters House was located between Wazee and Blake on Sixteenth Street. Buffalo Bill Cody, General Custer, Baby Doe

The writer of this 1881 letter, Frank, mentions that he gets meals, washing and lodging for twenty-five dollars a month. *Author's Historic Hotel Collection.*

Tabor, President Grant and Horace Greeley all laid their heads on the feathered pillows at the American House. This 1869 hotel was made of Denver brick and was located diagonally across the street from the Inter-Ocean. A letterhead from October 1894 referred to the two-hundred-room American House as the "Old Reliable." It was considered a first-class operation, boasting steam heat and illuminating gas in each room. In 1880, rooms rented for as much as $2.50 to $4.00 a day. Prior to the Windsor Hotel opening in 1880, this principal hostelry was known for its food and spacious dining room, having perhaps the best accommodations between the Missouri River and the Pacific coast.

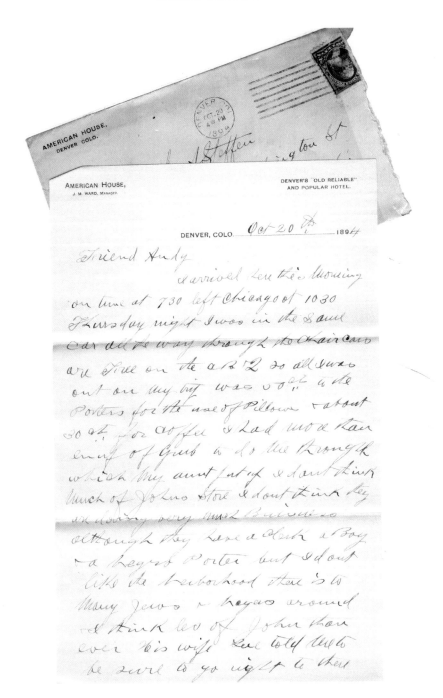

This traveler arrived by train and "was out 50 cents to pay the porter for use of pillows & about 30 cents for coffee." *Author's Historic Hotel Collection.*

Guests of the American House might have needed extra time to choose from the following turn-of-the-century Christmas dinner menu:

> *New York counts, consommé, Mock Turtle, cheese sticks, broiled bluefish, serpentine potatoes, fresh lobster à la Newberg, queen fritters, Siberian punch, roast prime rib of beef, young turkey with chestnut dressing, browned sweet potatoes, French peas, California crab with mayonnaise, Christmas pudding with hard and brandy sauce, Vienna puffs with whipped cream, orange meringue pie, Edam cheese, nuts, fruit, raisins, figs, American cheese, water crackers, coffee and New York cider.*

Giovanni Battista Cuneo, from northern Italy, arrived in Denver with his wife, Louisa, in the spring of 1872. They were the first Italian family to settle permanently in the city after being lured to Colorado with the news of gold and silver strikes. Giovanni owned and operated the American House Restaurant for years, before owning a grocery store where Union Station now stands.

A small, "less expensive" option in 1896 was the St. Elmo Hotel on the corner of Seventeenth and Blake Streets, one of twenty hotel choices on Seventeenth Street in 1920. The St. George, on Seventeenth near Wazee, operated from 1890 until 1937, offering both American and European plans to its guests.

The luxurious Inter-Ocean, opened by ex-slave Barney L. Ford in October 1873, was located on the southwest corner of Sixteenth and Blake Streets. The *Rocky Mountain News* announced in January 26, 1890:

> *Quite a celebrated institution was the restaurant kept by Ford, a colored man, on Blake Street between F (15th) and G (16th). He had the reputation of giving a better and squarer meal for less money than any man in Denver.*

Barney Ford, who came to Colorado during the gold rush days and became a prominent African American businessman and civil rights leader, is honored with a stained-glass mural in Denver's capitol building.

There were more commercial-type hotels, such as the Oxford Hotel of 1891; it catered to the business traveler, primarily men. This type of hotel was typically closer to the warehouse or wholesale district, where business would be conducted, making the salesman or businessman's journey a short route from his temporary home.

Day laborers and the working class on a low budget could stay in boardinghouses or furnished rooms usually found on the upper floors of downtown businesses.

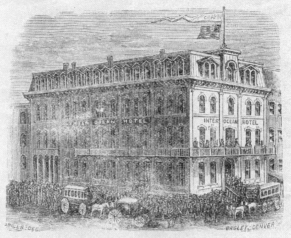

The Inter-Ocean

COR. 16TH & BLAKE STS.,

DENVER, COLORADO.

J. M. WILKINS, Proprietor

ARRIVALS AND DEPARTURES OF TRAINS.

DENVER TIME.

KANSAS PACIFIC
Arrives.. 5 40 p. m. Departs.. 7 05 a. m.
COLORADO CENTRAL.
Arrives..11.00. a m Departs.. 9.20 a m
" .. 4.45 p. m. " .. 3.00 p. m
" .. 7.05 " " .. 4.30 "
DENVER PACIFIC
Arrives.. 6.40 a. m. Departs.. 6.10 p m

BOULDER VALLEY
Arrives..10 40 a. m. Departs.. 3 30 p. m
DENVER & SOUTH PARK
Arrives.. 9 15 p. m. Departs.. 6.00 a. m.
DENVER & RIO GRANDE.
Arrives.. 5.10 p. m Departs.. 8.15 a. m.

Inter-Ocean's menu cover for Thanksgiving dinner and wine list mentions train arrivals and departures. Hudson's Railroad Ticket Exchange was located in the hotel office. *Author's Historic Hotel Collection.*

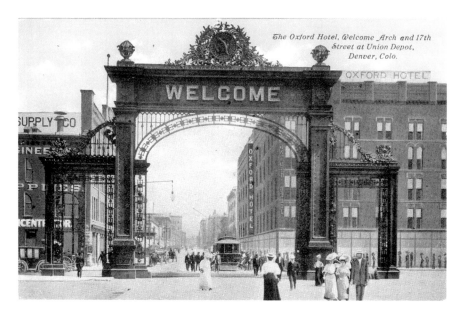

The Oxford Hotel (1891) was an easy walk for travelers arriving at Union Station. Only a one-cent stamp was required for this postcard. *Author's Historic Hotel Collection.*

Grand Central and the Oxford were located between Wynkoop and Wazee, straight up Seventeenth Street. The Oxford advertised on its letterhead: "Baggage to and from the Union Depot free of charge." Another publication, *Denver at a Glance*, advertised daily sight-seeing trips starting from the hotel by the hotel's own company cars and boasted that "the Oxford is one of Colorado's leading hotels. It is located just opposite Denver's beautiful new Depot. Has 300 rooms, three cafés and popular-priced dairy lunch room."

The Union, later renamed the Elk (circa 1905) and finally renamed the Barth Hotel (circa 1930), was located just down from the Oxford on Seventeenth and Blake Streets. This building, originally constructed as the Union Liquor Warehouse in 1882, was converted to a hotel in the late 1880s and is still standing today. It was designed by Fredrick Eberly, who also designed the Tivoli Student Union building and the Mercantile on the Auraria campus.

Hotels built with the middle class in mind advertised to attract families. These hotels were typically cheaper than the luxury hotels and often offered suites instead of just a room.

During the gold rush days, settlement hotels were built quickly with materials readily available in the West. These hotels typically had balconies

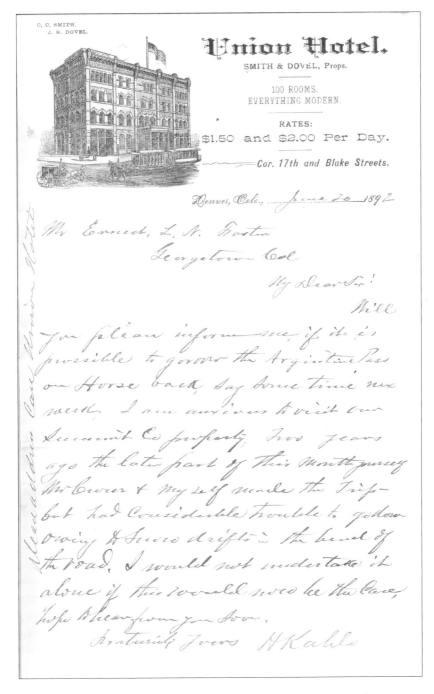

This hotel guest inquires whether he can cross Argentine Pass on horseback to visit his Summit County property if the snowdrifts aren't too deep. *Author's Historic Hotel Collection.*

This July 1909 Albany guest writes to his "baby doll" in Oregon, wishing she was with him in Denver. *Author's Historic Hotel Collection.*

where speeches could be made to local crowds below and porches for gatherings and shelter from the weather. Hotels were often centers of political events. Teddy Roosevelt gave a speech from the Windsor Hotel's balcony during one of his many visits to Denver.

Construction on the Albany Hotel, on the southeast corner of Seventeenth and Stout Streets, began in 1882, and three years later, in July 1885, the doors opened to guests. Buffalo Bill Cody, Annie Oakley, P.T. Barnum and General and Mrs. Tom Thumb were all overnight guests at the Albany.

Another famous guest of the Albany was Baroness Louise (Davies) Von Richthofen, who married Baron Walter Von Richthofen at the St. James Hotel on March 20, 1887.

Advertised as "Denver's Best Known Hotel," the two-hundred-room Windsor at the northeast corner of Eighteenth and Larimer Streets was a colossal five-story hotel. The Windsor opened its burly black walnut doors on June 23, 1880. Calamity Jane was the only woman allowed in the Men's Bar, which was sixty feet long and studded with three thousand silver dollars. Baron Von Richthofen held dinner parties at the hotel. Other famous guests included William Howard Taft, Theodore Roosevelt, Oscar Wilde, Mark Twain, poet Eugene Field, Buffalo Bill Cody and W.H. Vanderbilt.

The first corner building is the European Hotel, followed by Windsor stables and the Centennial Hotel. Union Station, prior to the 1894 fire, fills the rear view. *Author's stereo card.*

Horace and Baby Doe Tabor moved into five suites, including the Bridal Suite, in 1882. The balcony of the Bridal Suite is the same balcony where Teddy Roosevelt gave his political speech. Horace Tabor died in Room 302 on the third floor on April 10, 1899.

Chapter 6

WAR!

World War I

The United States declared war on Germany on April 6, 1917. Colorado's governor, Julius C. Gutner, stated in the *Rocky Mountain News*:

> *Colorado is shaped for war. The State is organized to meet any demand the nation may make. At the threshold of the New Year [1918] Colorado faces the war problem of future months with a council of defense in every county in the state. This means that our state is well advanced in preparation to bear its part and do its share in all of the services President Wilson had in mind when he said: "it is not an army we must shape and train for war; it is a nation," and it further means that Colorado's people, jealous to give their abilities and resources to the cause of the world's democracy and liberty, are coordinated and unified in organizations that can quickly and effectively translate into action the policies of their chief executives, state and nation. Thus prepared, Colorado will bend its energies in concentration upon the performance of the work.*

The National Guard of Colorado, well trained and well equipped, was considered one of the best organizations in the nation. More than eighteen thousand people registered that spring in Denver to serve the war effort; some four thousand of them were Colorado National Guard.

Congress and the War Department had agreed on the need to establish a military post near Denver back in February 1887. Three years after

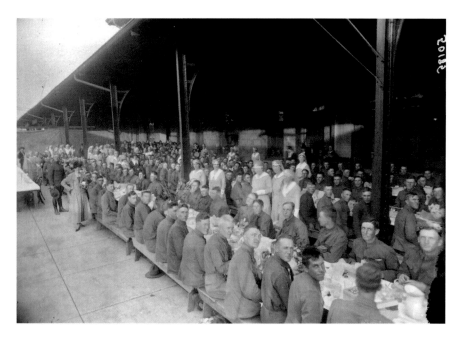

Harry Rhoads captured Red Cross nurses feeding World War I soldiers at Union Station. *Western History Department, Denver Public Library.*

construction began, what was originally called Fort Sheridan and later named Fort Logan was completed. Fort Logan would see thousands of drafted and enlisted men for outfitting and preliminary training before they headed out to other training camps in 1917 and 1918.

Local hotels and restaurants were asked to conserve food as an effort to help feed the thousands of Colorado soldiers. A 1917 *Denver Hotel Bulletin* reported that in one month, Colorado's hotels and restaurants were able to save enough food to feed 4,300 Colorado National Guard soldiers for a little over two weeks.

During World War I, all railroads were controlled by the United States Railroad Administration. Denver's depot was jammed with thousands of young men arriving each day.

Union Station provided a shower room and USO–Red Cross service center for the soldiers during the wars.

In November and December 1917, thousand of "Sammies" from nearby states arrived in Denver by train, soon to be outfitted at Fort Logan. During the recruits' stopover in Denver, Uncle Sam paid the nearby hotels fifty cents a night to accommodate as many of the men as they could. Hotels such as the Albany, Brown Palace, St. James, Standish, Shirley, Savoy, De Soto, LaCourt, Midland,

WAR!

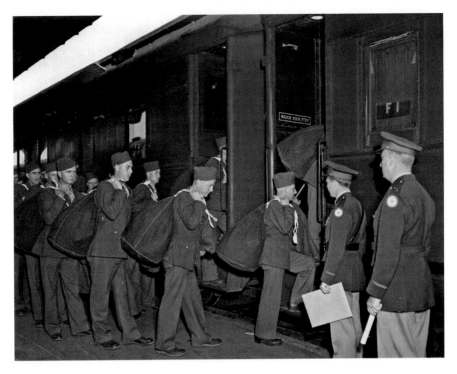

Young soldiers boarding the train at Union Station. *History Colorado Center, Stephen Hart Library, Denver Rio Grande Photo.*

Great Northern and Colorado welcomed many soldiers arriving in the city each day. As many as seventy-five soldiers might share as few as eighteen rooms. The Albany Hotel accommodated soldiers on cots in all of its banquet rooms and even in the hallways. Over two hundred Sammies stayed in the Midland, and the Great Northern Hotel also treated the soldiers to barrels of apples. Accommodating as many soldiers, if not more, than any of the other hotels was the hotel closest to the depot: the Oxford.

Some hotels not only provided the soldiers with sleeping quarters, as crowded as they were, but they also treated them to meals, music and dancing. The soldiers appreciated all the hospitality that Denver's hotels provided, as evidenced by one thank-you letter that was framed and hung in the Albany's office:

> *Sam. F. and Frank R. Dutton, Albany Hotel, Denver.*
> *We, the boys of the Nineteenth Company, Fort Logan, representatives of many states, take pleasure in thanking the management of the Albany Hotel,*

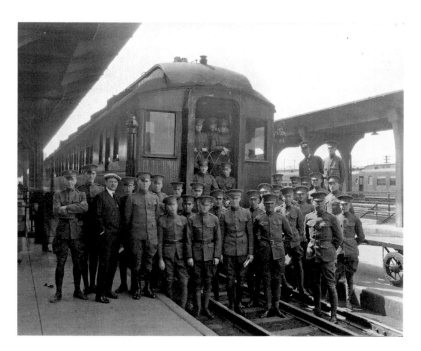

Brave and proud soldiers pose at the platform of Union Station. *History Colorado Center, Stephen Hart Library, Denver Rio Grande Photo.*

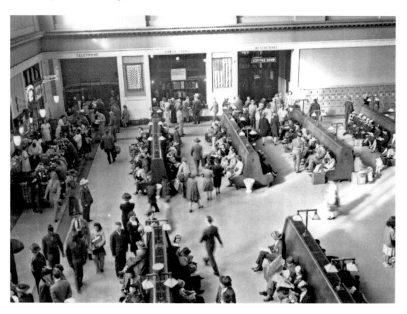

Another busy day with nearly every wooden bench in the waiting room fully occupied, a full luggage cart and every seat at the counter taken. *Western History Department, Denver Public Library.*

also the citizens of Denver, for the loyal attention and care given us during our stop-over here. No matter how hard the tack or fierce the struggling, this will always remain in the memory of each and every one of us. We further wish to assure you that we are more than willing to sacrifice our lives that the Liberty which we have always enjoyed may continue forever.

We wish you all the heartiest of success, and hope that someday we may be able to be with you again.

[Signed]
THE BOYS OF THE NINETEENTH COMPANY
Fort Logan, Colo.

Before the Treaty of Versailles was signed on June 18, 1919, more than forty-three thousand soldiers from Colorado had served in a war that took the lives of over fifteen million men.

World War II

In December, twenty-two years later, during Franklin Delano Roosevelt's second term as president, the Japanese bombed Pearl Harbor, and the United States and Britain declared war on Japan. Hitler took control of the German army and declared war on the United States—all in a matter of days. By January 1942, the first American troops had started arriving in Great Britain.

Again, each day Union Station was jammed with recruits arriving to train for war or soldiers saying farewell to their families as they departed to serve their country. Thousands of men trained at Colorado's Buckley, Carson and Lowry Fields or Camp Hale. Army Air Corps recruits were transferred by trucks to head east to Lowry Field, where more than fifty-seven thousand a year were trained during the course of the war.

The *Denver Post* reported on the holiday rush and volume of soldiers returning to Denver on December 19, 1945:

With thousands of service men struggling to come home for Christmas from west coast embarkation points, with students returning home from school and with heavy civilian transportation demand, plus a terrific flow of Christmas mail and freight, all of the transportation facilities in and out of Denver—rail, air and bus—were in the midst of their busiest and most hectic season in history Wednesday.

All train traffic in and out of Denver, with 75 per cent of passenger travel now used for military personnel, is at full capacity and the Denver union station is a beehive of activity. The troop trains passing thru Denver are running in far greater volume than at any time during the war, Charles R. Hines, station manager, declared.

While the problem of handling eastbound and westbound passenger traffic out of Denver is by no means as acute as that on the west coast, all regular mail equipment has become taxed to the upmost, Hines pointed out, adding, however, that "trains are seldom leaving anyone on the platform."

Extra rail cars from all lines in the United States have been diverted to west coast points in a prodigious effort to take care of the soldiers, sailors and marines waiting to come home, he pointed out.

"However, if you dump thousands of people in one spot there is bound to be a traffic problem," said Hines.

"Considering the facilities the railroads have and lack of replacement during the war, I think they're doing an amazing job.

"Here at the Denver station our freight, express and passenger business is the greatest in history. It has impassed a heavy strain but, with a good, hard-working crew, we're managing to keep up with it."

POSTWAR STRIKE

Just after World War II, a series of union labor strikes of over five million workers from numerous industries and utilities occurred. Meatpackers, rail and steel workers, coal miners, electric workers and the Brotherhood of Locomotive Engineers and the Brotherhood of Railroad Trainmen all threatened to bring the nation to a standstill. Immediate impacts were realized. The inability to move people, food and freight brought chaos to the nation, partially in the dispute over a less than twenty-cent-an-hour increase.

Five brotherhoods of the Denver and Rio Grande Western Railroad, representing some 2,500 union employees, threatened to join the strike in March 1945. The D&RGW, operating from Denver to Utah, was responsible for transcontinental shipments of army and navy supplies. The union dispute included three issues. The first issue was over additional pay—and in some cases, double pay—for certain types of rail cars, mail handling, express trains and baggage in emergency situations on passenger cars. The second demand was the employment of extra "hostling" crews—those who handle a locomotive

between runs, including taking it to the engine house and delivering it to the road crew—regardless of whether there was work for them to do. The third and final demand was for payment for in-town train crews.

A trustee of the D&RGW explained the brotherhoods' third position in more detail in the *Denver Post* on March 8, 1945:

> *The main point of difference is that every instance the brotherhoods insist that every train crew in town should receive a full day's pay because one crew was not called. Under our agreement with the brotherhood a day's pay is paid to the first crew up for the work if thru error such crew is not used. In these cases the brotherhoods now insist every crew in town should be paid, even tho they lost no earnings by reason of not being used.*

The *Denver Post* headlines on March 9, 1945, proclaimed, "President Acts to Avert Strike on Rio Grande." The brotherhoods would agree to call off

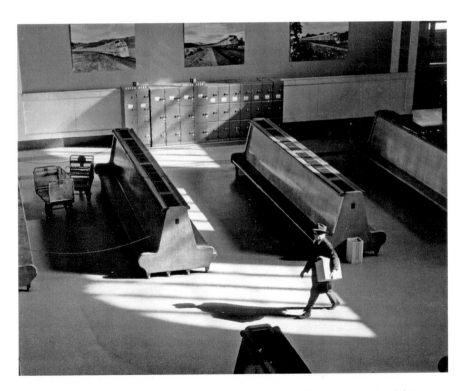

One of the few times the waiting area was empty was during the railroad strike. *Western History Department, Denver Public Library.*

the strike only when they received President Harry S. Truman's proclamation through their own national union offices.

On May 18, 1946, the Union Pacific was scheduled to depart Union Station with 1,600 ticketed passengers but temporarily was delayed from its evening departure because the switchmen did not receive official notice regarding the impending railroad strike.

After deciding that the unions had gone too far when the president of the Brotherhood of Railroad Trainmen refused to arbitrate and was determined to carry out the strike, President Truman announced from the White House on May 24, 1946, that the government would take over the operation of the railroads and break up any railroad strikes with the army.

President Truman continued his speech by stating:

The railroads must resume operation. In view of the extraordinary emergency which exists, as President of the United States, I call upon the men who are now out on strike to return to their jobs and to operate our railroads. To each man now out on strike I say that the duty to your country goes beyond any desire for personal gain.

Just minutes before the United States Army was about to seize control of the railroads, the railroad union leaders accepted President Truman's agreement and went back to work.

Chapter 7

SPECIAL EVENTS

GIVE ME LIBERTY

It tolled for the deaths of many great American men—Franklin in 1790; Washington in 1799; Hamilton in 1804; both John Adams and Thomas Jefferson on July 4, 1826; and Lafayette in July 1834. The Liberty Bell traveled by train to be displayed in New Orleans for the 1885 World Industrial and Cotton Exposition, to Chicago for the 1893 World's Fair (World Columbian Exposition), down south to Atlanta for the 1895 Cotton States and Atlantic Exposition, to Charleston for the 1902 Interstate and West Indian Exposition, back up north to Boston for the 1903 Battle on Bunker Hill celebration and again down south for the 1904 Louisiana Purchase Exposition before returning to its home in Philadelphia.

Over 500,000 California schoolchildren signed a petition requesting that the one-ton Liberty Bell once again be shipped by train to be displayed at the 1915 Panama-Pacific International Exposition in San Francisco. The World's Fair or International Exposition was to be a grand celebration of the completion of the Panama Canal and the recovery following the 1906 San Francisco earthquake.

The children's petition was successful, and the bell would now travel farther west than ever before. The Liberty Bell's journey of over ten thousand miles from the East to the West Coast would take five months by train. This was a great opportunity for many American citizens to see, photograph and even touch the Liberty Bell for the first time. The train stopped frequently in

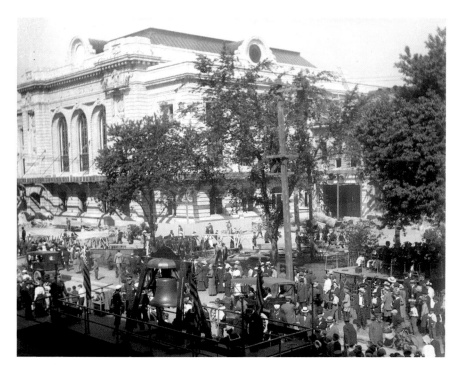

Hundreds gather to see the Liberty Bell, guarded by the navy, at Union Station. *Colorado History Center, Stephen Hart Library.*

numerous cities and towns in several states, sometimes for just a few hours, before heading on to its next destination. Enthusiastic and patriotic flag-waving crowds and politicians gathered at each train station on both legs of the journey, the northwestern route to California and a more southern route back east to Philadelphia, to see this historic, cracked "old State House Bell." Train stops included Indiana, Illinois, Iowa, Kansas, Missouri, Nebraska, Colorado, Utah, Wyoming, Texas, Oregon, Washington and California.

The July 1915 *Rocky Mountain News* reported:

> *It is particularly appropriate that the big bell should come to the capitol of Colorado in view of the fact that the state is known as the "Centennial" state, having been admitted to the union on the 199th anniversary of the year that the Declaration of Independence was signed.*

There was no doubt that Denver was excited to have an opportunity to see the historic Liberty Bell; the Friday, July 9 *Rocky Mountain News* front-page headlines read, "Liberty Bell Starting on Its Trip: Relic Will Be Here Tomorrow."

SPECIAL EVENTS

Each stop in the larger cities, like Denver, was a grand celebration, complete with gun salutes, whistle-blowing and brass bands playing. The iconic symbol of American independence, justice and freedom arrived in Denver at Union Station on July 10, 1915, on the Union Pacific Railroad.

It was estimated that some two thousand people were at Union Station to welcome the bell, with a "squad of the city's bravest and most imposing policemen who are to guard it until it is returned home." Bouquets of fresh mountain flowers adorned the exhibit. People bowed their heads before it, kissed it and rubbed their wedding rings on it for good luck, and the blind were led to the bell so that they could "see" it with their touch.

The morning after, the front page of the *Rocky Mountain News* proclaimed, "City Pays Tribute to Liberty Bell: Patriotic Fervor Fills Thousands."

ALL ABOARD TO WINTER PARK

Driven by the winter demand for skiing and transportation west to the snowy mountains, the D&RGW Ski Train was created in the 1940s. Each weekend, hundreds of skiers could board at Union Station; travel through twenty-nine tunnels, including the infamous more than six-mile-long Moffat Tunnel; and reach their destination of Winter Park Ski Resort. The approximately two-hour-long, fifty-six-mile train ride eliminated the need to be concerned about weather conditions, snow tires, visibility or the flow of traffic on today's I-70 through the Eisenhower Tunnel and over the Continental Divide.

In the 1970s, a ride on the Ski Train would cost $4.50, about the same as the lift ticket. For the sixty-ninth season, Ski Train passengers would pay $59.00 for coach and $85.00 for the club car, owned and refurbished by Denver billionaire Philip Anchutz.

The Ski Train ceased operation in 2009 due to high costs and freight traffic conflicts with the railroad.

In celebration of Winter Park's seventy-fifth anniversary, seventy-five-dollar round-trip Ski Train tickets were offered on Saturday, March 14, 2015. In less than ten hours, the anniversary Ski Train sold out, indicating Denver's enthusiasm to bring back the Ski Train. More than four hundred tickets to fill seventy-two rail cars were sold again on the next day in about four hours. Obviously, Denver harbors a strong passion for skiing and riding the rails.

UNION STATION IN DENVER

CATTLE AND THE NATIONAL WESTERN STOCK SHOW

Since the 1830s, rail cars have been used to transport livestock. Denver miners and railroaders were hungry for beef. Transporting livestock by rail without attending to them can lead to weight loss, hunger and thirst, stress, bruising, trampling injuries and even death.

The Atchison, Topeka and Santa Fe Railway 1948 rulebook listed only one rule regarding livestock:

> *Wishes of attendants regarding care of livestock should be ascertained and assistance rendered in caring for such shipments...In absence of special instructions, hog shipments should be watered as necessary. Particular attention must be given to stock unaccompanied by attendants.*

With the railroad expansion, cattle could be loaded into stock cars and transported longer distances to other major cities and stockyards. There was money to be made with cattle. No one realized that better than John Wesley Iliff, Colorado's largest and wealthiest cattleman. Wesley had contracts with the Denver Pacific to supply beef for the railroad construction crew building the spur from Denver to Cheyenne, as well as with the Union Pacific. Another hunter and meat supplier for the railroad was William Fredrick Cody, who got his nickname from all the buffalo he shot.

As reported by the *Denver Republican* on January 25, 1898, "Denver's importance as a trading point has long since been recognized by eastern cattle men, and is daily growing."

To promote Denver, in January 1898, the City of Denver and local ranchers hosted a free barbecue in the Denver stockyards for locals, the U.S. secretary of agriculture, the National Stock Growers Association and other leading livestock officials and delegates. Trains ran from the jammed Union Station to the Denver stockyards every fifteen minutes. The *Denver Post*, on January 28, 1898, described the crowds, proclaiming, "Never Before Witnessed in the History of the West—Cars Groan Under the Burden of Passengers, Who Fill Them from Roof to Brake Beams."

Although this was the first stock-related event in Denver, it would be followed by other such promotions by cattlemen and livestock commissioners on and off until 1906. This event became the birth of what is known today as the annual National Western Stock Show.

The first National Western Stock Show, held on January 29, 1906, was attended by an estimated fifteen thousand people, some traveling by train

from as far away as the East Coast. That first year, the Grand Champion Steer sold for twenty-three cents over market price. Horse-drawn carriages, streetcars and special trains from Union Station delivered many attendees to the stockyards. By 1909, a newly constructed amphitheater had been erected by the Denver Union Stockyard Company; this is the same building where the annual event is held today.

"DADDY OF 'EM ALL"

Each July, Cheyenne has hosted one of the largest outdoor rodeos since 1897, drawing over 200,000 to the event. Frederick G. Bonfils, *Denver Post Newspaper* co-owner, invited friends to ride with him on the inaugural special train, "in the spirit of the old West," in the summer of 1908 to the Cheyenne Frontier Days Rodeo. The special *Denver Post* train to Cheyenne became an annual event for hundreds, including mayors, governors, other politicians and business leaders and movie stars.

Other than a few exceptions (1924 and during World War II), the Cheyenne Frontier Days train was an annual event, running each summer until 1970. Denver's Mayor Stapleton boarded the train and enjoyed a steak dinner with over one thousand other enthusiasts the year after World War II ended, when the train resumed its annual journey to Cheyenne. Denver's mayor Wellington Webb and Governor Roy Romer rode the 100th anniversary train to Cheyenne in 1992, when tickets were once again offered. Today, extremely limited tickets for the twenty-car passenger train are offered through a lottery system to the annual July "Daddy of 'Em All" Rodeo in Cheyenne, demonstrating that people still love to ride the rail.

Chapter 8

REVITALIZATION

IMAGINE A GREAT CITY

Although Union Station had been the transportation center since 1881, it began to lose the battle to airplanes and automobiles in the 1950s. Adding the "Travel by Train" neon sign in 1953 wasn't enough to prevent the lure of faster or more popular methods of travel.

By the 1960s, the station saw fewer than twenty-three passenger trains a day while the city was being torn down all around it by the Denver Urban Renewal Authority to make way for modern construction and progress. Amtrak took over operation of passenger service in the early 1970s, and the station was perhaps saved from more threats of demolition by being listed on the National Register of Historic Places in 1974, all while Denver's population and economy were declining.

As the city rang in the New Year of 1980, Downtown Denver's office vacancy rates hovered at 30 percent, while as much as half the hotel rooms remained empty; however, the Regional Transportation District (RTD), the City and County of Denver and the Downtown Denver Partnership would be instrumental in the development of the 1.2-mile Sixteenth Street pedestrian mall with transit centers at both ends—a $75 million investment that would give life back to downtown.

The *Rocky Mountain News* reported in February 1983 that lower downtown was on the "verge of a rebirth" and that an overhaul of Union Station would be "crucial to revival." It went on to state:

A block from Union Station is a low-lighted business named the Terminal Bar
& Café that sells a glass of beer for 60 cents and a working man's breakfast
for a couple of bucks. Three blocks from the Depot a nouveau chic dining room,
The Manhattan Café, attracts a different clientele—food fanciers who prefer a
cloth cover on their tables and attendants who know the wine list by heart. The
menu includes African rock lobster and Long Island duck. The two eateries
typify lower downtown's urban schizophrenia. One distinctly blue collar and
well-worn. The other upscale and neatly appointed. Both are part of the same
neighborhood—but probably not for long. The city of Denver and five railroads
that own Union Station have an idea that may transform lower downtown out
of its grit and decay once and for all.

Under study by the City Council is an idea to build a convention center
behind Union Station. A 1,000 room hotel and some office space to go with
it. Also looming is a possible three-block extension of the 16th Street Mall to
connect downtown with its long-neglected neighbor, lower downtown. The idea
is simple enough. But many are concerned that the development on that scale
will clash with lower downtown and perhaps destroy its character—something
the city saw value in last year when it approved a zoning revision that offered
incentives for preservation. Property owners who bought lower downtown land
for $15 a square foot—or less—suddenly will have a distinct incentive to
"build out" to a full density if the convention center arrives.

"Imagine a Great City" was Mayor Peña's campaign slogan in 1983.
Denver's first Latino mayor had big dreams for Denver and the citizens to
back him. Peña's administration convinced the railroads to consolidate and
remove thirty railroad tracks in the Platte Valley Rail Yards behind Union
Station, which resulted in about two hundred acres for future development.
Despite the fact that property values were falling, Denver voted to raise
property taxes to support a $280 million bond issue for infrastructure projects
to rebuild the city. Denver's dependency on the oil and gas industry nearly
crushed it when the price of oil plunged to less than $10 a barrel in 1986.
Unemployment soared to 7.4 percent that year, barely above the national
average. Union Station escaped demolition threats and plans to move the
station closer to stockyards, as the plan to develop Central Platte Valley was
created in the 1980s. The station and the land behind it, all the way to the
South Platte River, remained undeveloped.

After the negotiations to develop the Union Station area into a convention
center were dropped, other plans were discussed. In the fall of 1987, the
Denver Post revealed another development plan for Union Station:

REVITALIZATION

Denver's Union Station would be preserved at least another 50 years under a soon-to-be-signed development agreement, but its two flat-roofed wings could be torn down and replaced with 25 story office towers.

Although the agreement reaffirms a decision made by city officials nearly two years ago, it's under attack from preservationists pushing for tight new demolition controls in lower downtown, neighborhood activists and Historic Denver Inc.

Kathleen Sutton of Historic Denver, Inc. was quoted by the *Denver Post* as saying, "Those two old wings are older than the main hall itself. And if you put two 25 story towers in there it's completely out of character with the scale and size of the other historic buildings."

Joel Warner reminded us of the importance of saving the railroad station and developing the transit center around it as a centerpiece in his 2008 *Westword* article:

Many U.S. cities outside the East Coast have long since turned the wrecking ball on their deteriorating grand railroad stations or made them into shopping malls. Denver never did so, thanks in part to nostalgic and forward-thinking civic boosters like "Save Our Station," a citizen's group that included John Hickenlooper, years before he was mayor, which helped stave off Union Station's potential demolition in 1988.

"It's a tremendous opportunity for Denver to have a historic building with as much emotional attachment to it and have it so centrally located," says Marilee Utter, president of Citiventure Associates LLC and former RTD development specialist. "Usually when you have a transit center like that, it's in the middle of nowhere."

In the late 1980s, there were more discussions about what to do with the station and the railroads. The *Denver Post* reported in July 1989:

Talk about moving Denver's main railroad terminal away from Union Station has quieted because the railroads using the station seem to want to stay there. The decision to maintain the train service at the station delights members of several groups, who have been trying to keep 75-year-old Union Station alive. One backer of keeping trains in the station has collected more than 3,000 signatures on a petition to keep the train service there.

At the time, the city was studying the cost to either elevate the tracks with a partial viaduct or to take the tracks below ground level, both of which would be

very costly, making it an easy decision for Mayor Peña's administration to keep the tracks at grade. The *Denver Post* again quoted Historic Denver's concerns:

> *"We don't want to see the station close down, because an empty building is always at risk," said Kathleen Hoeft of Historic Denver's historic preservation committee. "We think it's appropriate, especially when people are trying to promote downtown Denver, that you bring a lot of your tourists directly into Denver."*

In 1989, there were two different opinions about whether the railroad tracks should be relocated or remain where they were. The *Rocky Mountain News* captured the opposing thoughts in December of that year:

> *The downtown business people wanted the tracks out because they are a barrier between downtown and the Platte Valley. And this was the number one item on the agenda of the business people, to get the viaducts out of lower downtown.*
>
> *Officials of the Ski Train, owned by Denver industrialist Philip Anschutz, have told the city planners they want to remain at Union Station. Nationally, they market the train's accessibility—where tourists can walk from their downtown hotel rooms to the ski lifts.*

Mayor Wellington Webb took office in 1991 with the knowledge and vision to keep people downtown by creating parks and amenities, such as sports and cultural activities, to draw them there. Again, Denver and the metro counties supported the mayor's vision with a sales tax increase to help fund the $300 million ballpark in lower downtown. The Webb administration developed a thirty-acre Commons Park along the river between Fifteenth and Nineteenth Streets, the first development in the Central Platte Valley, and funded $46 million to clean up the polluted waterway. The Regional Transportation District bought Union Station and the 19.5 acres behind it for $40 million in the summer of 2001. Before Webb left office in 2003, the population and economy of Denver was on the rise.

The debate over how to best use Union Station was still making headlines in 2000, when the *Rocky Mountain News* reported:

> *Activist Kenton Forrest remembers when millions of travelers a year streamed through Union Station, when impatient locomotives hissed on 12 tracks just west of the station and when 80 trains a day chugged in and out.*

REVITALIZATION

A station agent once told me he had to step over people all the time, much like they do at [Denver International Airport]," said Forrest, a historian at the Colorado Railroad Museum. That was the 1920s, '30s and '40s. Today, the four story Union Station is a concrete hulk staring vacantly over lower downtown, its waiting room witness to barely two Amtrak trains a day and the Ski Train to Winter Park. Is it the end of the line for the grand old building? Some say so, contending that the aged station is a white elephant too costly to renovate or even maintain. Better to bulldoze the building and begin again, they say. "It makes no sense investing huge sums of taxpayers' money in something we don't need," said Jack McCrosky, a Regional Transportation District board member. "It's a white elephant the owners are bent on unloading."

But others, including key transit planners, city officials and the station's owners, have a different vision. They see new life for the grand old edifice, a rebirth of rail transportation and a new use for the building as a transit hub for the metro area.

The future of the station made headlines on a regular basis. Everyone had an opinion on what should or could be done to the older station, whose "glory days were gone." In September 2000, the *Rocky Mountain News* quoted Fredrick Ross Company, a downtown real estate broker at the time:

Union Station is the gateway to downtown. What's in the works is a huge deal. It won't be easy...but it's going to happen. I guarantee if you leave Denver and come back in 18 months, you're not going to believe what's taken place.

Despite one RTD board member's opinion that the station wasn't worth the taxpayers' money and that it was a white elephant, a *Rocky Mountain News* article of May 2001 reported that RTD's board approved the purchase of the station. Tom Noel's article read:

Once upon a time, Coloradoans built a fast, efficient rail network.
From Denver's Union Station, a spider web of steel stretched to nearly every hamlet in the state. Travelers arriving at Union Station could stroll across Wynkoop Street to the Denver Horse Railway Co. for a 5-cent streetcar ride to any of Denver's neighborhoods or suburbs. Alas, for the past 50 years we've been paving over and ripping up railway and streetcar tracks. The resulting automobile hyper-dependency is apparent to anyone. Now the Regional Transportation

District is reaching into the past to find a cure for traffic congestion—the major complaint of Coloradans as long as the weather or the Broncos aren't acting up. Not only has the agency resurrected rail cars (witness the shiny passenger coaches zipping along beside crawling cars and SUVs), but it wants to bring Union Station back to life as the region's ground-transportation hub (the board has OK'd $60 million to buy the historic station).

A partnership of Denver consultants, hired by RTD, the Colorado Department of Transportation and the Denver Regional Council of Governments, studied whether and how the station could be converted into a transit hub and how the remaining acreage could be developed for commercial and residential needs at the cost of thousands.

As many as eight companies bid on the opportunity to become the master planner and determine the future of Union Station. Applicants were from both coasts and everywhere in between—New Jersey, New York, Texas, San Francisco, Kansas City, Chicago and our own beloved Denver.

Regardless of the costs and other financial difficulties the city might have faced in 2003 and concerns that led to an audit by Denver's city auditor, Dennis Gallagher, the study had to continue, so the additional cost was endorsed by RTD and the joint venture.

Redevelopment plans were revealed numerous times, including in the fall of 2003, for public comment and the Denver City Council's consideration. Many of the plans were for high-rises or office towers that exceeded the zoning of the area and would dwarf the historic station.

Sierra Club transportation chairman and Union Station Advisory Committee member Bert Melcher reminded everyone of the importance of the historic station when he said:

As one of the founders of RTD in 1969, we have long hoped to restore Union Station as the major transportation hub for Metro Denver. We wanted it to be a highly visible symbol of the past and future glory of Colorado's proud rail heritage. These new towers will hide the neighborhood's crown jewel from nearly every angle...This is such rich history that it should be respected and left fully visible.

A light-rail system called FasTracks, a massive $4.7 billion transit project with 122 miles of rails and 18 miles of dedicated bus lanes, was approved in November 2004 by the voters after the new mayor, John Hickenlooper, sold the idea to the citizens.

REVITALIZATION

Preservationists again had their say about the future of the historic station and decreed in May 2004 that the original 1880s wings must stay, the *Denver Post* reported:

> *A group of prominent historic preservationists has launched a campaign to oppose construction of 65-foot-high buildings on both sides of Denver's Union Station. The Respect Union Station Ad Hoc Committee says the proposed structures would block views of the 123-year-old Union Station from some angles and would wipe out valuable open space.*
>
> *Some leading the campaign served on a volunteer panel in November [2003] and endorsed a master redevelopment plan for Union Station. But they have since changed their minds about one aspect of the plan.*

The Respect Union Station Ad Hoc Committee wanted to keep the 1880s wings, preserve the oldest portion of the historical structure and give people open space, a place to linger.

Dozens of developers had an opportunity to take a tour and see the station and surrounding properties in June 2005. Some realized the station had not changed much in more than a century with the exception that it had become "dingy."

Bob Wislow, chairman and chief executive of U.S. Equities Realty in Chicago, said it best when he said, "It's not what I see here today that matters; it's what could be there in the future that has me so excited."

Among the eleven teams of developers in the 2005 race to be selected to develop the Union Station project, Donald Trump and his son responded to the Request for Qualification (RFQ) but did not meet the minimum criteria to be considered. Although business mogul and New Yorker Donald Trump is well known, he was certainly not the best choice. Many believed his short response to the RFQ meant he did not have the station or Denver's best interest in mind. The committee wanted someone who would focus on Denver and show a real commitment to the project. Others believed the fact that Trump was even interested indicated that the Denver real estate market was getting hotter. The announcement of Trump's interest spurred newspaper cartoons depicting what his redevelopment might look like: "Trump loves 'transit' and sees the site as the perfect spot for a luxury Trump International Hotel and Residence Tower, complete with personal penthouse helipads and a 4-story all marble limo garage."

As early as October 2005, there were plans submitted to develop a plaza on the east side of Union Station. Everyone agreed that the plaza should be

more than just an entrance to the station. Fred Kent of Project for Public Spaces Inc. developed the report and was quoted in the *Rocky Mountain News* on October 27, 2005, as saying:

> *There's no major transportation center I know of in the world—and I travel 150,000 miles a year—that uses a great square in front of the transportation center as a major destination. It will raise the bar and other places will have to come to that level. The vision for the plaza is both a front door to the city and the region and a social gathering spot for the community, the report said. "Denver already has many great places," the report said. "Union Station Plaza should join the ranks as one of the 10 great."*

Dana Crawford, a member of the Friends of Union Station, had the right idea; she believed the plaza had to serve everyone, from commuters and tourists to kids and neighbors.

Until a master developer was selected for the redevelopment of Union Station, other repairs and upkeep were still required at the station for the few Amtrak passengers who used it. In December 2005, the *Denver Post* shared some of the housekeeping improvements being made by RTD, the current owner of the historic building:

> *Wanted: three Renaissance Revival chandeliers 13 feet high, for a great room. RTD facilities manager Richard Rost thought a recent auction of antique lighting had just what he was looking for to brighten the cavernous waiting room of Denver's Union Station. The chandeliers for sale were the right size for the train room and its 66-foot ceilings, which now has large, uninspired fluorescent fixtures. The proposed price of the antique lights—up to $25,000 apiece—was manageable for RTD. But the fixtures' Gothic Revival style was not in keeping with the station's history, so Rost didn't bid. "We passed it by the Landmark Preservation Commission staff, and they agreed it was too ornate," Rost said. Working with a $5 million budget, he is leading the partial renovation of Union Station, which has sections that date to 1881. The station's train room was rebuilt in 1914. The Regional Transportation District is making only essential improvements and repairs. Much of the work of restoring the historic station will be left to a master developer, who is expected to redo the space as part of the planned $800 million redevelopment of Union Station and its surrounding 18 acres. That redevelopment could take 15 years or more. The station will be the*

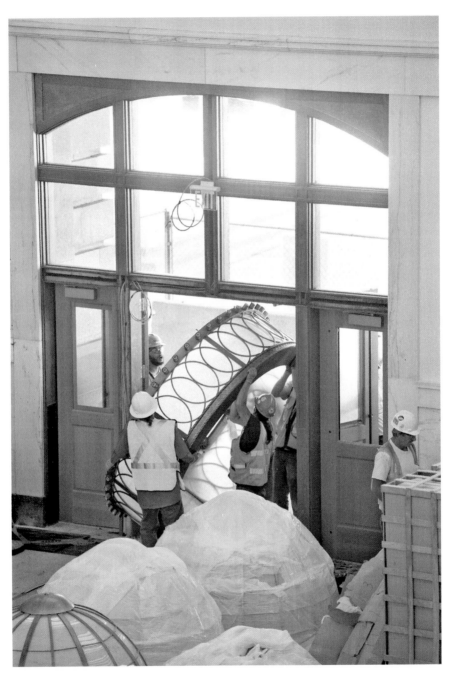

How many men does it take to get a light fixture through the waiting room's doorway?
Courtesy of Ellen Jaskol Photography.

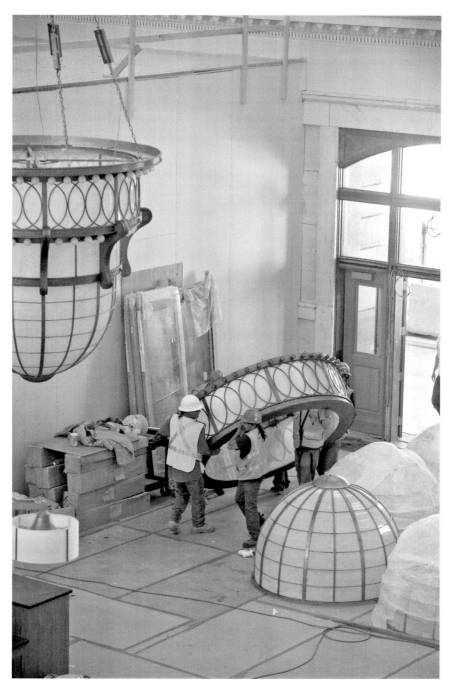

The size of these light fixtures becomes much more apparent in comparison to their surroundings at this close range. *Courtesy of Ellen Jaskol Photography.*

hub of RTD's transit system when the agency's $4.7 billion FasTracks expansion is finished in a little more than a decade.

To stay faithful to the historic building's architectural styles, Rost uses old photographs to guide the renovation, and proposed changes are run by Denver's Landmark Preservation Commission and the Colorado Historical Society.

"Richard is doing a superior job," said Everett Shigeta, a preservation architect on the staff of the landmark (preservation) commission. "Union Station is one of the premier historic buildings in Denver." Some items couldn't wait for selection of a master developer. Rost had the Rail Car Diner removed from the west wall of the station. When the diner came out, it exposed 90-year-old woodwork around doorways that needed repair and refinishing. Probably the most visible restoration was work done on the "Union Station" and "Travel by Train" neon signs that adorn the station roof. For about $63,000, the signs were taken down for glass, gas and transformer repairs and other upgrades. The refurbished signs now are back up.

Soon, contractors will replace asphalt roof shingles with clay tiles that mimic roofing materials used long ago.

When it came to lighting improvements, Rost had an option beyond looking for antique fixtures: He could fashion replicas. The area through which rail passengers walk to the train platforms was dark and foreboding. To light up the area, Rost found historic designs of pendant lights in photographs of the station's old telegraph office. For $50,000, he had three lights fabricated in the same style, only much bigger. They now hang in the foyer. Attempts at faithful restoration also can fail.

For nearly $12,000, RTD contracted for patching holes in the terrazzo floor where the diner was removed. The contract included honing, or polishing, the floor in that area. Terrazzo is made of small pieces of marble or granite, set in concrete or epoxy and then given a high polish. On a recent walk-through of the station, Rost shook his head at the obvious color mismatch of the repair work, with white terrazzo patches standing out sharply against the pinkish stone floor that most likely dates to the 1914 reconstruction. RTD's contractor on the project "just didn't spend the time with the color matching," Rost said. The contractor has agreed to redo the work and get the proper match. "I'm chipping away," said Rost, as he pointed out the cartouches, sconces and pendants that give Union Station its grand feel. "I wish I could do more."

Just one month before a master developer would be selected, there was a "design duel" between the last two potential developers: Union Station Partners and the team of Continuum/East West Partners.

Their plans for Union Station and the immediate parcels surrounding the station were in contrast to each other. While Union Station Partners' plan included two hotels and condominium towers with commuter, light rail and bus transportation modes coming into the station underground, the opposing plan by Continuum/East West Partners kept light rail at street level and included a grocery store and a large-format retailer. East West Partners already owned real estate parcels near Union Station and in the Central Platte Valley.

Union Station Partners proposed a forty-six-story tower, while Continuum/East West Partners proposed nearby buildings no higher than twenty-two stories, which pleased the president of the Colorado Historical Society, who wanted Union Station to be the focal point. Tryba Architects also liked the East West Partners plan because of the street activity proposed.

The decision on which development team would be chosen to redevelop Union Station was the responsibility of the members of Union Station's Executive Oversight Committee (EOC). The four representatives chosen to represent the committee were Cal Marsella, general manager of the Regional Transportation District, who was involved with RTD's purchase of Union Station; Peggy Catlin, deputy executive director of the Colorado Department of Transportation; Jennifer Schaufele, executive director of the Denver Regional Council of Governments; and Peter Park, manager of community planning and development for the City and County of Denver, previously hired by Mayor John Hickenlooper.

Dana Crawford, urban developer, preservationist and board member of the Friends of Union Station, the remaining citizens group, voted to endorse the Union Station Partners' development plan, although she saw merit in both plans. Brad Buchanan, architect and team member of the Union Station Partners, welcomed support from others and stated that although their plan was more expensive than their competition's, they wanted others to realize that the decision is a "one-hundred-year decision."

The headlines of the business section of the *Rocky Mountain News* in November 2006 read, "Fate of the Union." It was becoming more apparent that Continuum/East West Partners' redevelopment plan would be chosen over that of Union Station Partners, endorsed by the Friends of Union Station.

Joel Warner of Westword and Jerry Nery of RTD summarized what lay ahead for the potential master developing team:

REVITALIZATION

Both teams faced a daunting task. The redevelopment would be one of the largest publicly supported construction projects in the city since [Denver International Airport], one that involved cramming two types of railroad lines, a bus terminal, shuttle stops and significant commercial development into a 19.5-acre swath of land saturated with underground utility lines, low-level railroad contamination and stormwater drainage from much of downtown, all without interfering too much with the historic structure, the busy roadways around it or the handful of trains that currently use the site. As Jerry Nery, RTD engineering manager for Union Station, puts it, "It's kind of like adding ten pounds of potatoes to a five-pound bag."

The next day's headlines read, "All Aboard" as the master developer was announced. The master developer would be responsible for designing the future of the transit hub. Plans for the restoration of the historic structure itself would be separate from the transit master plan. Although it would be at least a year before construction would begin, the city had a project developer. Details of the contract would be finalized over the next few months with Continuum/East West Partners, which changed its team name to Union Station Neighborhood Co. The biggest change in the plan was the decision not to bury heavy rail but to keep it at ground level behind the station.

Walter Isenberg, president of Sage Hospitality, part of the Union Station Partners team, stated, "Our view was, this is a project that's really a legacy project for the city of Denver. It has the potential of impacting the quality of life and the quality of downtown for the next hundred years...Cost should have been a secondary consideration to design."

Created in 2008, the Denver Union Station Project Authority's role would be to finance, design and build a regional transit center linked to Union Station, while the remaining fifty-five acres around the station were slotted for private development. The Regional Transportation District was pressured to do something with the historic structure it now owned and which would be fully surrounded by new development. Although Union Station was at that time unfit for occupancy per building codes, it was an important architectural jewel to be revitalized. The Regional Transportation District developed a Request for Proposal to obtain proposals for the historic structure.

Dana Crawford, a Denver preservationist, envisioned a hotel within the station and sold others on her big idea. She reminded us of how this project could do so much for downtown when she said, "When the Civic Center was built in Denver, what a huge impact it had, and really, this is one of the great

sites in Denver of the twenty-first century. It will be impossible to exaggerate the impact of it."

Proposals were received and short-listed to two viable plans for the adaptive reuse of the station. Continuum/East West Partners proposed office and retail space, while the Union Station Alliance proposal included, in addition to retail space, a plan to build out a hotel in the upper floors of the station. The hotel idea for the station had an added economic advantage: a lodging tax. Tryba Architects was granted a sixty-year lease to maintain the building on behalf of RTD.

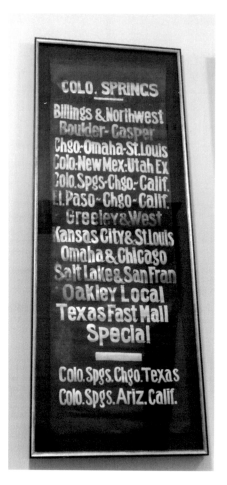 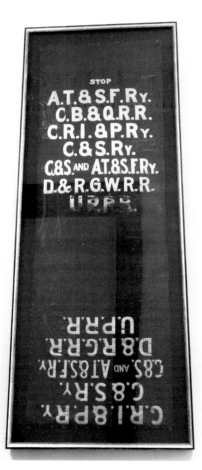

Left: Original scrolls, once used to announce the train departures, now reside framed on the wall next to the new ticket window. *Courtesy of Gary Hubel.*

Right: Scrolls depicting the trains that operated out of the station were found (hidden in the basement vault) during the station's renovation. *Courtesy of Gary Hubel.*

REVITALIZATION

As Denver started a new decade, the last Ski Train departed Union Station, Kiewit Western Company was selected as design-build contractor for the transit portion of the project and a $300 million grant was received so construction of a new commuter rail station could become reality.

A very large and complex transit system was about to transform the city. Union Station Alliance was selected to complete the project and received a ninety-nine-year lease for the property in 2011. With Dana Crawford's inspiration and preservation experience, the Union Alliance would bring life back to Union Station and the surrounding area.

One important benefit offered by the soon-to-be-selected master developer and a point of persuasion in the final decision was mentioned by Tom Tobiassen, the Regional Transportation District director, in the *Denver Post* in December 2011:

> *"Once the information comes out, people will see why we're voting the way we are," he said. "The* [Union Station Alliance] *proposal has a very long-term package that will provide complete operations and maintenance of the building so taxpayers won't need to subsidize the building for at least 60 years."*

The following year, the somewhat dormant historic building closed to the public for interior demolition and restoration by the general contractor, Milender White Construction Company.

BIG BUCKS: FINANCING THE PROJECT

Marilee Utter, executive vice-president of the Urban Land Institute's Global District Council program, commented on avoiding letting the cost impact the importance of doing it right:

> *The people behind this have a lot of good instincts. They have hired great designers. On the other hand, everyone is acting poor...money is really tight, so I hope we don't make any short-sighted decisions. If people start cutting corners with materials or connections, that will hurt it. If the historic station is not part of the functional connectivity, that will be a travesty. The heart and soul of the whole district should be that building. If the transit doesn't work as a seamless connection for people, that's a problem. If the development isn't dense enough, that's a problem. If the public space doesn't*

become a great space, that's a problem. Everybody has a crazy story about the building. It's just amazing how deeply people care about what happens to it. I think that's really a mandate to invest in it and do it right.

In July 2008, a nonprofit corporation, Denver Union Station Project Authority (DUSPA), was formed by the City of Denver to finance and implement the project. RTD took over ownership, operation and maintenance. The overall partnership took ownership upon completion of each element. DUSPA, the project's sponsor, consisted of RTD, the City and County of Denver, the Colorado Department of Transportation (CDOT), the Denver Regional Council of Governments and Union Station Neighborhood Co.

In May 2009, the design-development phase began for this nearly fifty-acre unique project. Such an extraordinary undertaking to transform Denver's historic Union Station into a regional multi-modal transportation hub required vision, creativity, commitment, coordination and financing. Initially, the fifty-acre project area included the historic building, rail lines and tracks and approximately six acres of vacant parcels of land that were to be sold and developed into a mix of residential, retail, hotel and office space. The transportation hub portion of the project, just under twenty acres, which ultimately used the historic landmark station as its centerpiece, connects commuter rail, light rail, bicycle and pedestrian access and several modes of bus transit, including a new Downtown Circulator service and the extension of the Sixteenth Street Mall shuttle service.

Just as Marilee Utter stated, the team hired great designers and invested in "doing it right." Interconnecting public spaces, including Wynkoop Plaza, Wewatta Pavilion, Seventeenth Street Promenade and gardens and the new Light Rail Plaza, were designed and constructed as part of the overall project.

The budget included a $201 million regional bus facility, a $154 million passenger rail, a $67 million light rail station and $58 million in streets and plazas development.

Trammell Crow Company worked with Denver Union Station Project Authority to arrange over $300 million in federal loans. Overall project funding included multiple agencies: a Transportation Infrastructure Finance and Innovation Act loan, $145.6 million; a Railroad Rehabilitation and Improvement Financing loan, $155.0 million; a U.S. Department of Transportation Federal Highway Administration grant, $45.3 million; a U.S. Department of Transportation Federal Transit Administration grant, $9.5 million; an American Recovery Investment Act

stimulus grant, $28.4 million; Homeland Security, $353,000; a Regional Transportation District contribution, $65.1 million; other state and local funds, $19.9 million; and land sales, $18.4 million.

After years of negotiations and planning, the project was ready to go forward.

WHAT LIES BENEATH: DENVER'S BUS TERMINAL

As Gwen Anderson, executive director of the nonprofit Union Transport Development Corp., once told the *Denver Post*, "We're not talking about just building a bus station. You'll have a transportation center, a thriving housing and commercial development. If it's done right, it could become a thriving center of activity for the whole city."

May 9, 2014, the closing date for the old Market Street bus station, was the opening date for RTD's new Denver Union Station Bus Complex. There's more than what meets the eye; beneath the train shed, some twenty-five feet below grade, lies an impressive twenty-two-gate bus depot, where as many as seven skylights and glass pavilions not only bring in the warm sunlight but also give it the appearance and feel of being larger.

Designed by Chicago architect Skidmore, Owings & Merrill (SOM), the bus terminal is approximately 1,000 feet long by 140 feet wide and has more the feel of an airport. SOM created a bright bus terminal by using natural light, slanted walls, terrazzo floors and bright yellow tile. Buses arriving and departing are visible to the passengers through the large interior glass windows.

The terminal concourse pavilion and plaza areas provide a pedestrian connection between the bus facility, light rail, commuter rail, train platforms and Union Station itself. The Chestnut, Wewatta and Union Station Pavilions provide multiple entrances to the underground bus concourse via a combination of escalators, stairs and elevators. Landscaping was designed by SOM in collaboration with Hargreaves Associates, which also designed the water fountain plaza area on Wynkoop.

Once underground, large monitors near the entrances provide scheduling and messaging information for the sixteen regional, express and local bus routes. With over one thousand buses passing through each day, the air filtration system of the bus transit center is critical. Air is monitored in six zones throughout the concourse, and creative "air curtains" are used to separate the bus lanes and prevent fumes from entering the terminal. Eighty exhaust fans run throughout the concourse, with three larger exhaust fans

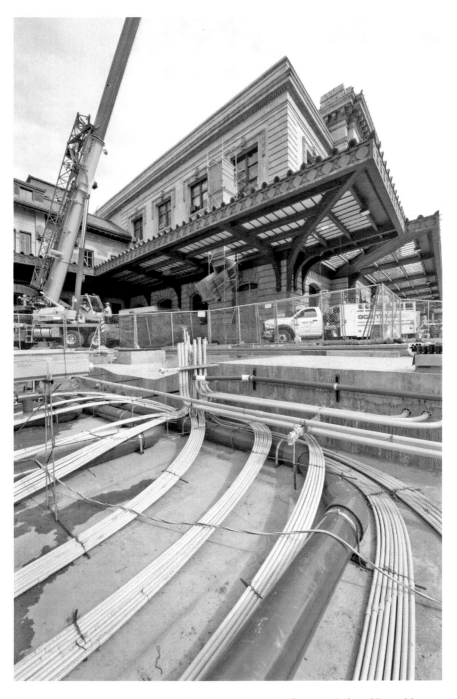

Underground piping and conduit for the plaza's interactive fountain designed by architects Hargreaves Associates. *Courtesy of Ellen Jaskol Photography.*

that filter the air at the north end of the station and up through the three, large, decorative exhaust stacks built above the concourse.

Construction and overall transit project management was the responsibility of Omaha-based Kiewit Infrastructure Co. and other subsidiaries, Kiewit

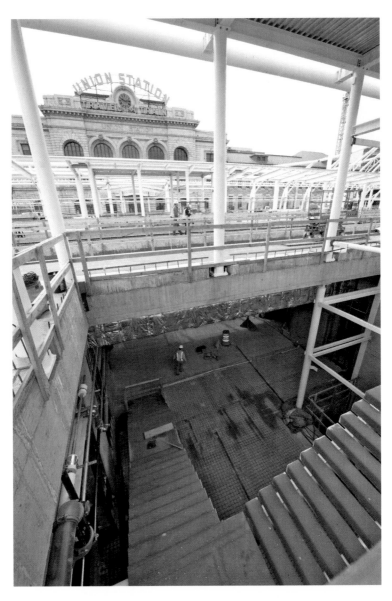

There is no escalator yet for the twenty-two-gate, $500 million bus concourse.
Courtesy of Ellen Jaskol Photography.

Building Group and Mass Electric Construction Co. During the peak of the project, over two hundred Kiewit workers were on site.

How much dirt has to be excavated to pour a four-foot-thick concrete foundation to accommodate a forty-thousand-square-foot underground bus concourse? "More than 360,000 cubic yards of soil—enough to fill a 20,000-capacity sports arena over nine times—and over 270,000,000 gallons of water—enough to fill an Olympic-size swimming pool over 400 times," according to Kiewit. Groundwater was pumped out, filtered and released into the South Platte River as the excavation occurred. The nearly one-thousand-foot-long, $200 million bus concourse was excavated and built in two stages. To keep the underground bus concourse leak-tight, the foundation rests on a "floating slab" of concrete that is four feet thick. Exterior walls are two feet thick.

While digging the facility, without underground plans or maps, Kiewit workers found old luggage, service tunnels, old utility lines and even, much to their surprise, cow bones.

The largest and most complex transit program encompasses eighteen miles of rapid transit bus service, twenty-one thousand new parking spaces at rail and bus stations and expanded bus service, including a new Free MetroRide shuttle that runs from Civic Center to Union Station via Eighteenth and Nineteenth with unique, distinct "bus bulbs" stops to make passenger loading easier.

In the summer of 2015, the Colorado Department of Transportation started operating a new bus system called "Bustang Bus," whereby riders can catch an inexpensive, comfortable ride from Union Station south to Colorado Springs, as far north as Fort Collins or via Interstate 70 as far west as Glenwood Springs.

Denver commuters now enter and leave from a very modern and effective bus terminal.

The Train Hall's Sky Hole

Trains were the original reason for Union Station, and the design kept it the heart of the district. As early as 2010, welding of the rail into four-hundred-foot strands began. Later, to make a continuous rail, the four-hundred-foot strands were welded together and then welded to the turnouts. In January 2013, erection of the train hall canopy trusses began while commuter rail

REVITALIZATION

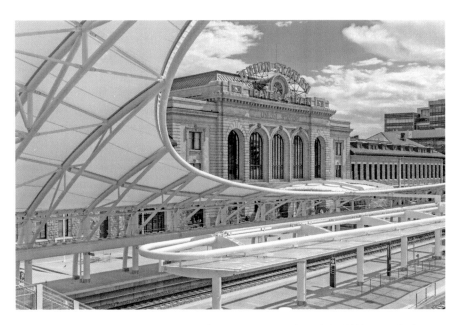

The historic Union Station is artistically framed in the opening of the Skidmore, Owings & Merrill (SOM)–designed canopy. *Courtesy of Gary Hubel.*

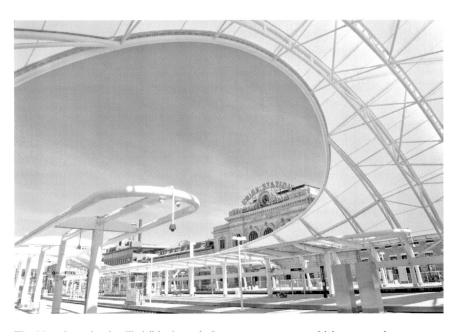

The historic station is still visible through the canopy structure, which protects the passenger platforms below. *Courtesy of Ellen Jaskol Photography.*

train hall canopy steel fabrication took place off-site. Commuter rail tracks, track turn-outs, train hall canopy and trusses (structure on platforms) and the new rail platform are required to serve all eight tracks of rail, which narrow down to five tracks at the Twentieth Street Bridge.

The train hall protective cover is a 40,000-square-foot canopy made of polytetrafluoroethylene (PTFE) fabric, like that at Denver International Airport. It gradually becomes wider from the 22-foot center to some 70 feet at each end. Support of the 500-foot-long canopy was accomplished by eleven steel "arch trusses" constructed of steel tubes that are spaced 180 feet apart. To ensure the views of the historic station were not obstructed, SOM designed what is referred to as the "sky hole" in the dramatic white canopy. A light-sensitive timer controls the lighting in the train hall so that they come on at dusk and go off at daylight.

Rails to Denver

When the subject of a lack of parking near Union Station was brought up by the public, Tom Gougeon, project executive of Union Station Neighborhood Co., replied, "I know people are interested in parking. Truthfully, we are spending millions on transit so we don't have to get here by car."

Union Station Transit Improvement Project transformed and revitalized Denver's historic Union Station into a regional multi-modal transportation hub connecting many areas miles away in all directions directly to the heart of the city. While the city has had light rail since 1994, RTD's FasTracks Program expansion plan added 119 miles of new light rail and commuter rail, 18 miles of rapid transit bus service and the capability to serve an estimated 25 million passengers in Denver and the greater metropolitan region annually.

Union Station is the historic centerpiece of the $6.2 billion regional light rail system and mixed-use development. Skidmore, Owings & Merrill (SOM), a subcontractor to Kiewit, designed the multi-modal transit hub for buses, light rail, commuter rail and Amtrak service that Kiewit Western constructed.

By 2016, the commuter rail "A" line from the airport to Union Station will carry an estimated ten thousand people a day with a train arriving every fifteen minutes. The ride between Denver Union Station and Denver International Airport on commuter rail will open in the spring of 2016 after each individual train car receives one thousand miles of testing. The short

twenty-three-mile ride from downtown to the airport will be about thirty-seven minutes and cost ten bucks, less than RTD's SkyRide bus fare each way. Once again, travelers and commuters will be able to ride the rails to Denver, making Union Station and the surrounding area the city's commercial core, as it was when the depot was first built.

A NEW LOOK TO AN OLD STATION

The historic station itself was the last piece of the overall project. The master plan did not include plans for the station itself. The public relentlessly pressured RTD into doing something with the building; after all, it would become the centerpiece of all the development surrounding it.

While the Denver Landmark Commission has jurisdiction of only the historic building's exterior, the National Park Service has jurisdiction over the entire site, including the interior.

To take advantage of potential hotel space in the historic structure, the team again negotiated with the National Park Service to create a partial mezzanine level for hotel rooms by dropping the ceiling in the north and south wings where restaurant kitchens are located. As an example of this clever idea, as one sits at the bar area of Mercantile Dining & Provision, you can look above and see a portion of the floor and exposed partially frosted glass wall for the hallway to the rooms located on the mezzanine level.

More dormers could be added to the train hall side of the station because, with the addition of the canopy, there was no single advantage point to see the entire exterior of the building, satisfying the Denver Landmark Commission's concern of altering the exterior view.

Team member Dana Crawford also approached Tryba Architects with her idea to apply for a state historical grant, which could provide an estimated $200,000 to be used for replacing the exterior canopy glass, which is supported by large wrought-iron brackets and rods and attached to the building by lion head–shaped supports.

The original glass was not "safety" glass; it was determined to be unsafe, with the glass panes themselves too large to handle calculated loads or possible hail storms. Therefore, the glass had to be brought up to code and replaced. During the preexisting assessment of the building, it was also determined that some of the structural steel supports for the glass were rusted and deteriorated and needed to be replaced. The architectural team

Construction progress in the basement during the summer of 2013. Note the contrast between the brick wall and the original stone on the right. *Courtesy of Ellen Jaskol Photography.*

designed a new canopy with smaller safety glass panes and intermediate structural members that so closely resembled the original canopy that, again, the Denver Landmark Commission could not tell the difference.

The original south wing of the basement had previously been used as a crawlspace for the station and was only partially dug out. During the design and construction phase, it was determined that it would accommodate what would become the Stoic & Genuine Restaurant's mechanical backup location. Due to Amtrak's previous use of the crawlspace, the dirt that was excavated by hand was considered hazardous waste and had to be remediated appropriately. During the excavation of this space, a large pile of bones was discovered. After analysis by authorities, the bones were determined not to be human but rather those of a large animal. Conclusions were made that perhaps during the original 1880s wing construction, an ox, horse or mule being used to pull carts or wagons could have died, and the easiest way to dispose of the large body was to just bury it there in the crawlspace rather than trying to haul it off the premises.

The acoustics in the Great Hall, due to so many hard surfaces, were not going to be suitable for what was to become Denver's new "living room," a place where people could gather, mingle, work on computers, drink and

socialize, so the entire room had to be scaffolded so that workers could apply a German-manufactured acoustical product to the entire barrel-vaulted ceiling.

Periodic inspections were made as the acoustical product was being applied, which meant the inspectors also had to climb up and walk across the scaffolding floor to access all areas—fondly dubbed the "dance floor."

The architectural team also took advantage of the openings in the ceiling where the three previous large lights had been attached in such a way that they could be lowered to replace light bulbs and raised back into position some sixty-five feet above by using the opening as an air return. This negated the need to cut additional openings in the ceiling.

Although the original wood trim and glass from the station's office doors were saved and reused, to prevent hotel guests from hearing any sound that might come from the Great Hall, precautions were taken to install new acoustic walls behind each hotel door.

Once the station's new look was completed, it was time to celebrate. Sage Hospitality secretly hosted the Clinton Global Initiative on June 26, 2014, in the Great Hall before the building was officially open.

While the public opening of the station had to be postponed, the Grand Hall and hotel were ready for viewing.

It was announced that the party of the century would be held, a "Great Hall Gala" to be hosted by the business partners who redeveloped the station. Even at $1,000 per ticket for this truly elegant black-tie celebration, the event sold out, to one thousand people, with all proceeds going to more than fifty different charities. The gala organizers went to great lengths to ensure that everyone would be entertained. While it was acceptable to kiss in the station, no one would be allowed to fall asleep. Although, when it did come time to rest your eyes, an additional $3,000 would get you a room at the luxurious Crawford for the night—and you could be among the first persons to ever pay to sleep in the station.

Denver literally rolled out the red carpet in front of the station for the July 11, 2014 event. Mayor Michael Hancock, the only speaker, was brief and stated that Union Station had put the "heartbeat back in Denver."

There were ice carvings, a roasted pig, a speakeasy and lots of music and dancing. To encourage guests to move around the Great Hall, gourmet food and drink stations with delectable nibbles were set up in different locations. The Union Station Alliance toasted all its guests with champagne, and First Lady Mary Louise Lee, a contestant on Season 9 of *America's Got Talent*, wowed everyone when she sang "America the Beautiful," a song written by

a woman who was inspired while riding a train across the Unites States and while in a carriage ride to the summit of Pikes Peak, here in Colorado.

The gala was attended by many politicians, executives, socialites, CEOs and presidents of many well-known Denver organizations and businesses. It was a night to remember and a great way to honor the station and all those who worked so hard to create a new look for the 134-year-old historic landmark.

The next day, the Crawford Hotel officially opened to the public. There were still more parties to come when, two weeks later, on July 26, 2014, Denver Union Station opened to the public with a large-scale street fair. Three bands played in the streets, there were plenty of family-friendly activities, beer and food were served and building tours were offered, all free to the general public. Dana Crawford was the first person to enter the station that day.

CLAIM TICKETS AND A PLACE FOR YOUR LUGGAGE

The financial force behind the remodel was the number of hotel rooms that could be developed. Tryba Architects, one of the members of the Union Station Partners' proposal, made assumptions that would be challenged again and again as the station's restoration took place. Tryba originally estimated, with the insertion of the mezzanine level and additional dormers, that it could create as many as 130 rooms, at least on paper.

The National Park Service oversees the federal tax credits, which were critical to the financial decision of the planned restoration and remodel. Without the approximately $8 million tax credit, the plan was dead. These tax credits could be sold for cash and used as needed to finish the remodel.

Dana Crawford, members of Tryba Architects and Walter Isenburg of Sage Hospitality got together for one of their many brainstorming sessions to come up with a creative plan to ensure that they would be successful in receiving the tax credits. They set a rule that every hotel room had to have a minimum of one window, which was accomplished during the design phase by using the dividing section of the casement window as the common dividing wall of two rooms. To satisfy this rule in the attic level, it meant adding a couple of stairs from the entrance of the room to elevate the main floor so the guest had a view out the window.

Although the process was a year in the making, the National Park Service allowed the Union Station Alliance to add dormers to the roof of the

building's 1880 wings and approved a historic tax credit, all critical elements to the success of creating a hotel in the upper levels of the station. Once the new dormers were added in the upper structure, Tryba Architects challenged the National Park Service to distinguish the new dormers from the old by viewing the exterior of the building. The design and construction were so successful that the National Park Service could not tell the difference.

The new mezzanine ultimately would give the architects the additional twenty-two rooms needed to make the hotel financially viable for the owner, Sage Hospitality.

The station was historically preserved with a few modern additions. The weight of the new roofing system and tiles had to be structurally supported in the attic.

The Union Station Partners team also decided to embrace the oddity of each hotel room, created by the structure's layout and attic space. While they exposed many beams in some upper rooms, others were encased. The Pullman-style rooms broke every rule in the book when it came to typical hotel architectural design. Since these rooms ended up being no wider than ten feet to respect the existing historic windows, creative adaptations had to be made, such as placing the bed directly against one of the walls. Custom TVs were designed and installed that allowed the guests to see the screen from any angle or location in the room. Bathrooms were slightly oversized in comparison to the bedroom itself to give the overall feeling of more space. Sage Hospitality and its investors have found that the Pullman rooms are their more successful hotel rooms within the station.

One architect offered his perspective of the hotel's challenges. "A hotel probably presents more challenges to keeping the historic integrity of the building intact," said Dennis Humphries, chairman of the commission. "But that doesn't mean they're insurmountable. There are a lot of great examples of hotels being put into old buildings. I wouldn't say that should be considered a deal-breaker, but the design team has some challenges."

Tryba Architects, in conjunction with JG Johnson Architects as a consultant, designed the hotel, which is managed by Sage Hospitality, which in turn operates as many as eight hotels listed on the National Register of Historic Places. Milender White completed the construction of the glamorous hotel for approximately $40 million.

Initially, Sage Hospitality wanted to name the Union Station hotel after Dana Crawford, Denver resident, preservationist and Union Station advocate, to honor her for all her work. But Dana, being the humble person she is, did not want the hotel named after her. Sage Hospitality's second

This photo gives a great view of the depth of the construction project. *Courtesy of Ellen Jaskol Photography.*

choice was to name the hotel Cooper, like the bar in the mezzanine level. However, when Sage Hospitality could not get "Cooper" to clear trademark research, Walter Isenberg, president of Sage Hospitality, part of the Union Station Partners team, was finally able to convince Dana to let them name the hotel after her.

Sage Hospitality announced on November 13, 2013, that the 112-room boutique hotel occupying the upper floors of the north and south wings of Union Station would be called the Crawford Hotel, in honor of Dana Crawford. No one deserved it more considering all Ms. Crawford has done for Denver.

The check-in counter for the boutique hotel was located just before the entrance to the 1880 north wing. Each unique room of the Crawford falls within one of three categories:

1) glamorous private sleeping car–style rooms located on the second floor, referred to as the Pullman guestrooms
2) contemporary-style rooms on the third level, referred to as classic guestrooms
3) attic-level rooms with vaulted ceilings and exposed wooden beams referred to as loft guestrooms

The rooms were decorated to reflect different eras of the building's history. One third-floor room incorporates the previous railroad office safe as part of its design. Claim tickets, coins, movie star photographs and newspaper clippings that were found inside the original waiting room's benches were preserved, framed and hung on the second floor of the hotel as a remembrance of days gone by.

The 1914 original architectural renderings of Gove and Walsh, which were found during demolition and cleanup of the station, were hung on the walls of the hotel staircase landing as a reminder of the center structure's origin.

Throughout the hotel and the entire station are nearly six hundred pieces of hand-picked art, selected by NINE dot ARTS, that focus on Colorado's artists. Each room is a beautiful space to place your luggage.

The Crawford Hotel guests may also share the Oxford Hotel Club Spa & Salon, another Sage Hospitality property, and meeting rooms just up Seventeenth Street.

Additional hotel amenities include a fitness center and three thousand square feet of meeting space located in the basement of Union Station.

On the basement conference center wall is a noteworthy piece of art one would not expect. Union Station sits right on top of the 105th meridian, a line of longitude that extends from the North Pole to the South Pole, where

Preparing the attic for additional hotel rooms. *Courtesy of Ellen Jaskol Photography.*

it bisects Denver. Some say it represents "forward progress," which seems to define Denver quite well. The meridian is also marked by a bronze strip between the granite pavers near the front door of Union Station, another one of Dana Crawford's ideas.

While there was much controversy over whether or not a hotel should be included in the redevelopment of the station, some believed that a hotel would ensure the preservation of the historic character of the building, and that is exactly what the architectural team accomplished. Additionally, the Union Station Alliance plan, with a boutique hotel, demonstrated an economic plan to generate an extra $100 million for taxpayers and no fewer than one hundred new jobs and overall exceeded many of the project goals of RTD.

Time and again, regardless of the unique challenges, the team redesigned and redefined the hotel rooms to create a successful layout to accommodate the number of rooms required to satisfy

Claim tickets found inside the old heated wooden benches, which could not be saved due to asbestos. *Courtesy of Gary Hubel.*

Sage Hospitality and its investors, as well as receiving as many tax credits as possible and maintaining the overall construction schedule.

There was much excitement as demolition began in February 2013, when the original iron staircase was exposed. *Courtesy of Ellen Jaskol Photography.*

A mystery seal engraved in the original masonry stone foundation, perhaps left by the original constructors of 1880. *Courtesy of Gary Hubel.*

Architectural details of the basement vault. *Courtesy of Gary Hubel.*

UNION STATION IN DENVER

A Mighty Thirst and a Nibble

The mining towns of Colorado were notorious for having more saloons than any other type of business, and Denver was no different. The city boasted at least thirty-five saloons, in addition to a couple breweries and a distillery in the 1860s. And now, there's no shortage of spirits, brews and other means to quench one's thirst in the revitalized Union Station.

Entering the station from Wynkoop, there is approximately 100,000 square feet of retail space with many unique, Colorado-themed retail places to choose from. On the east side of the old waiting room, now referred to as the Great Hall and "Denver's Living Room," is the Terminal Bar, previously located at Seventeenth and Wazee Streets, right up the street from the station's front door.

The remodeled original ticket office utilizes the original ticket windows with Belgium black marble counters trimmed in Yule marble. Where at one time you could get information, send and receive telegrams and purchase Pullman coach tickets, the Terminal Bar today pours more than thirty Colorado draft beers and serves locally distilled spirits for thirsty tourists and locals.

Directly above the Terminal Bar, the Cooper Lounge, an elegant, intimate bar, overlooks the Great Hall with sixty-five-foot vaulted

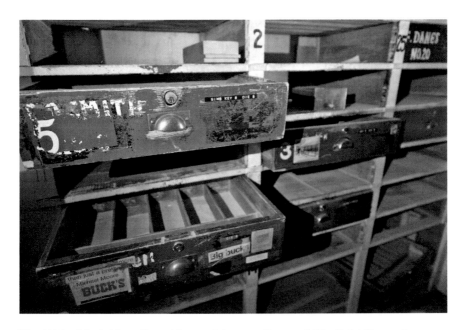

The 1914 original ticket office cabinet and drawers. *Courtesy of Ellen Jaskol Photography.*

Prior to the renovation and adaptive reuse for the Terminal Bar, this 1914 ticket window provided information for those expecting a train arrival. *Courtesy of Ellen Jaskol Photography.*

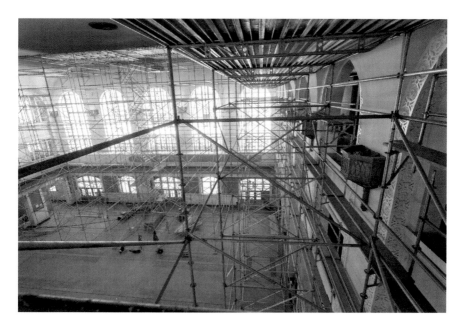

Once crowded with soldiers and their loved ones, the waiting room looks rather empty here, except for the scaffolding. *Courtesy of Ellen Jaskol Photography.*

ceilings in one direction and a view down Seventeenth Street from one of the many twenty-eight-foot cast-iron windows from Union Station's second floor.

It is a great location to see the decorative plaster columbines that surround the arches and windows up close, the Yule Creek Valley white marble pilasters that flank both sides of the ceiling and three chandeliers that resemble the original ones installed in 1913 and enjoy a view of downtown from one of the three two-story windows.

Just as it was during the station's active times, in April 2011 the *Denver Post* announced the plans for food to be offered twenty-four hours a day to serve travelers passing through:

> *"We're working with local chefs to create a collection of food and beverage spaces," said Joe Vostrejs, chief operating officer of Larimer Associates, which would handle restaurant and retail for the project. "When you come to Union Station, you'll know you're in Colorado."*

Using recycled subway tiles and the original mirrors, the old barbershop in the southeast corner of the historic building was transformed into the

A detailed view of the freshly painted columbines. *Courtesy of Ellen Jaskol Photography.*

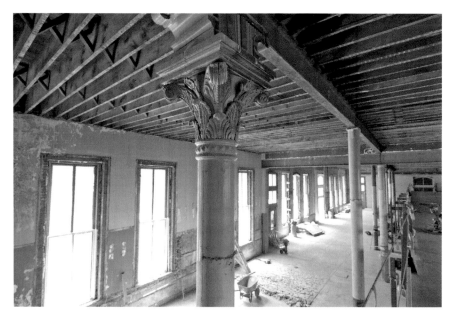

The original 1880 wing, stripped down to bare walls and ceiling studs. *Courtesy of Ellen Jaskol Photography.*

Milkbox Ice Creamery, where over fifteen flavors of hand-churned ice cream and shakes laced with liquor were served.

Next door, previously a smoking room off the main waiting room, locally roasted Novo coffee and pastries are served at Pigtrain Coffee, a space now beautifully decorated with butcher block tabletops. Grilled homemade burgers and brats on custom buns are served with hand-cut French fries at Acme Burger & Brats, located on the south side of the Great Hall.

In the south 1880 wing, occupying over 1,900 square feet, Jennifer Jasinski's (chef and owner of Rioja, Bistro Vendôme and Euclid Hall in Larimer Square) Stoic & Genuine offers seafood, complete with granita and an oyster bar.

In a space where the American Express Railway once operated and that was later used as a baggage room is the Kitchen's Next Door Restaurant. In 4,432 square feet at the far south end of the wing, the community pub serves Colorado beers and roasted beet burgers, as well as other casual foods. Next Door and Stoic & Genuine both have outdoor seating on the patio overlooking Union Station's new plaza fountain.

For those with less time to sit and dine, the Fresh Exchange offers healthy food such as salads, sandwiches, wraps and smoothies inside the

Great Hall, in the northwest corner next door to Five Green Boxes, an eclectic gift shop.

Located near an area where the 1926 dining room was once located is Bloom, a gift boutique with home décor and jewelry, with a separate stand-alone flower kiosk just in front of the train hall side door.

Above where the passenger subway tunnel once existed is Tattered Cover, Denver's favorite independently owned bookstore.

Across from Tattered Cover Bookstore, in a two-thousand-square-foot space, is Snooze, serving breakfast and lunch.

Where mail and express packages were once handled, at the far north end of the 1880 wing, is Alex Seidel's (Food & Wine's Best New Chef of the Year 2010) restaurant, Mercantile Dining & Provision. A portion of the nearly 4,900-square-foot space of Mercantile sells everything from dilly green beans, spices, pastries and the best espresso coffee, in addition to cheese and charcuterie from its Fruition Farm and creamery near Larkspur, Colorado. Gourmet dining is available in the remaining space.

Dining at Union Station has come a long way from days of one-dollar fried chicken at Gunn's Restaurant in the 1930s, the onyx soda fountain and other food concessions the Barkalow brothers offered during their forty years at the station. The Barkalow brothers owned and operated most of the Union Pacific restaurants, including those in Union Station. Their operation included a dining room and a small lunch counter.

The *Colorado Prospector* reported on July 3, 1881, "The Barkalow Brothers are well known all over the western country as owing all the western train privileges. That is, they supply the trains with fruit, books and all that makes travel pleasant upon the western lines."

Sometime during the 1920s, the Barkalow brothers sold the restaurants to Mr. Gunn, who, a little over a decade later, sold both the restaurant and the newsstands to J.O. Stoll. The USO took over the lunch counter area in the 1940s to support the soldiers. In the 1950s, the dining room was remodeled into the Caboose Lounge and Continental Room, and the Denver News Company took over the newsstand.

When the new Continental Room opened, it made the news as being one of the largest restaurants of its kind in the nation. The *Denver Post* reported on August 1, 1950:

> *The new Continental room at Union station opened Tuesday to complete a $140,000 redecorating and remodeling job on the dining room, cocktail lounge and coffee shop at Denver's railroad terminal. Joe Morton, vice*

president and general manager of the Denver News company which operates the restaurant, said seating capacity of the combined facilities is 320 persons...The mirror-lined Continental room has complete dining facilities. It is air-conditioned, has direct fluorescent lighting concealed in the walls and deep-pile wall-to-wall carpet. Adjoining it is the new Caboose cocktail lounge, completed last month and already, in Norton's words, a favorite spot for "bon voyage" parties. For the convenience of merchants and workers in the station area and for between-train snacks for travelers, the coffee shop offers streamlined service and moderate prices.

The restaurants turned over ownership no less than six times from the late 1950s for the next three decades. A packaged liquor store, the Longhorn Bar, was built in one of the small rooms off the waiting room in the 1950s, as was a snack bar nicknamed Glass House Jr.

Long gone are the emergency hospital, the jail, the Western Union telephone and telegraph room, the barbershop, the gents' waiting room, the check and newsstand, the smoking room, the immigrants room, the bake shop, the soda fountain, the express companies, the engineer's locker room and separate toilet, the women's powder room, the library and the mail rooms.

LINKING IT TOGETHER

In 2008, Joel Warner of Westword reported on the progress of what was being considered for the landscaping and plaza areas of the redeveloped Union Station.

Friends of Union Station, a grassroots organization formed in February 2005 to champion the importance of these spaces, called for an urban square, a game area, a public market, information and food kiosks, and an extended plaza across Wynkoop Street to make the thoroughfare more pedestrian-friendly. Over the past year, student teams at the University of Colorado Denver have also developed concepts—everything from a Spanish Steps–like grand staircase leading up to the 18th Street plaza, to public art evoking the immense welcome arch that once stood in front of the station, to a renewable-energy plant built into one of the plaza's side buildings. All of these suggestions will be taken into consideration by landscape design consulting firm Hargreaves Associates as it develops a

general plan for the spaces over the next few months, says Mary Margaret Jones, a senior principal at the firm. Some of the Friends of Union Station members formed a new alliance, the Open Space Initiative Group, which vehemently opposed the buildings on the grounds that they would diminish the station's visual significance and limit opportunities in the plaza. "This is one of the most important buildings in Colorado, and one of the most sterile parking lots around could be made into one of the most exciting places in Colorado," says member Bert Melcher. "The plaza needs a lot of room to do what postage stamp–sized spaces can't do. Those are okay for neighborhood purposes, but for something like this, it needs to be big." The remaining Friends of Union Station held a different view, and they formed their own group, Union Station Advocates, to continue championing the station's public spaces and embrace the wing buildings. "We think it will help activate the space in the plaza and frame the station," says co-chair Luke O'Kelley. "In good urban design, you want to frame a space so it is not strictly open space running into highly trafficked streets."

The *Rocky Mountain News* reported on the Union Station Advisory Committee's review of the evolving plans for the open space areas in February 2009. The Union Station Advisory Committee is made up of more than ninety-five people representing more than thirty groups and has the task of reviewing and agreeing on the plan for the public spaces. The *News* went on to say:

The urban design framework for a successful public space along Wynkoop Street was by far the most discussed and studied component of the master plan. Key points that the majority ultimately agreed on were that active edges and clearly defined spaces are common attributes of the public spaces we admire.

Tyler Gibbs, urban designer and manager of planning services for the city, wrote in his memo to the Denver Planning Board:

A plaza space with active ground-floor uses surrounding it will be more successful and attractive space. This activity will be created through the presence of ground-floor retail and restaurant uses that frame the space…While the historic building will provide considerable transit-related activity, its historic architecture does not allow for the types of large openings or windows that invite interaction between the station and the plaza or accommodate high-visibility retail.

UNION STATION IN DENVER

Kathleen Brooker, former Historic Denver president, also stated in the plan:

> *It is not the intent of* [the committee] *nor its preservation representatives to freeze the building in its existing context, surrounded by parking lots. Union Station has evolved, sometimes dramatically, over time...Establishing strong edges with bookend buildings should enhance the entire site while still providing visual access to the station.*

Judy Montero, councilwoman, told others back in 2009, "We can all be proud of the extensive and transparent public process that is guiding the creation of dynamic and optimal public spaces at Denver Union Station."

Landscape architects Hargreaves Associates designed the nearly eight of the thirty-four-acre site in conjunction with support from a Boulder's landscape design firm. There was no less emphasis placed on the public spaces than on any other portion of the overall project because these areas tie it all together.

On the back side of Union Station, Seventeenth Street Gardens is a contemporary design that links Union Station to Light Rail Plaza. The plaza areas surrounding the station are landscaped with trees, flowers and shrubs; granite pavers; and bench seats.

Where perhaps ducks once floated in the original pond before the original depot was constructed, there is now an interactive half-acre water fountain located in the south half of Wynkoop Plaza, which is not only beautifully lit at night but also serves to help drown out local traffic noise.

Just as the original depot once had a landscaped "garden park" to greet passengers arriving at the station and exiting out onto Wynkoop Street, the train station is again surrounded by beautiful landscaping. A grove of trees and some areas of planted gardens landscape the far end of Union Station's Wynkoop Plaza.

Wynkoop Street is named to honor one of Denver's early pioneers and founders, Edward Wynkoop, nicknamed "Ned." Wynkoop arrived in Colorado Territory during the gold rush of 1858. A man of many occupations, he worked as a miner, sheriff, bartender, land speculator and U.S. Indian agent. May the landscaping and dancing water fountain continue to honor this early pioneer for many decades to come.

REVITALIZATION

TRANSFORMATION

Union Station is more than just a train stop. As the 2014 *Denver Post* business section stated:

> *Overall, the project will be a mix of things old and new. The many details that could be preserved from the station's 1914 rebuild remain. That includes the iron awning over the entrance, now painted a forest green, interior ticket windows, marble walls and much of the ornate trim around doorways. But the station has been upgraded from top to bottom. Architects added an entire new floor, squeezing a mezzanine between the first and second levels. They slathered six inches of acoustical plaster on the tall atrium ceiling and carved out space for a museum in the basement. Other alternations are intended to animate the building on a daily basis and turn it into a busy civic meeting place. A sidewalk-level fountain in front will spout 300 streams of water—yes, you can run through it—and the plaza along Wynkoop Street will be filled with public seating. Inside, the grand lobby will be outfitted with twelve street lamps and a raised platform.*

The walls and ceiling undergo necessary prep work. *Courtesy of Ellen Jaskol Photography.*

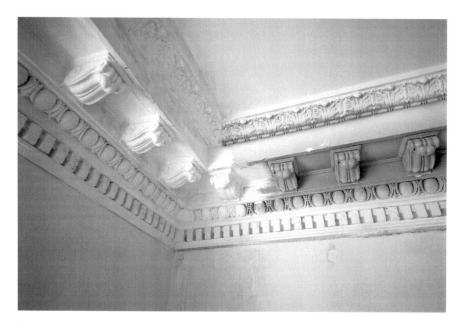

By June 2014, painting had begun. *Courtesy of Ellen Jaskol Photography.*

There are many attributes of the redevelopment of the former rail yards and the adaptive reuse of Denver's Union Station. It gave breath, purpose and a new meaning to the historic structure. It gives pride to the city and its people and created a new urban center. Beyond making the planner's vision a reality, restoring a landmark or building the nation's largest transit hub, this project did so much more for Denver. It cultivated pride of our heritage, and it proved once again that historically significant buildings and properties boost the economy and property values.

Union Station is currently at the center of one of the hottest real estate markets. As projected by Peter Park, Denver's manager of planning and business development,

> *the advantage of creating a central hub of transit is that it provides a significant opportunity for redevelopment. In the best cities in the world, the central train station becomes the premier address to be. Transit-oriented development creates the certainty of a critical mass of people getting on or off a bus, light rail or a ski train to provide an economic engine.*

Just as the newly built depot on the undeveloped end of the city once saw hotels, saloons and other businesses begin to circle it, the adaptive reuse of

the train station has done it again. The Lower Downtown historic district now has one of the lowest commercial vacancy rates and highest rental rates in the city. Central Platte Valley is exploding in residential and commercial development. No fewer than twenty-five new construction projects began in the neighborhood because of this multimedia transit development.

In April 2014, just a short time before the project was complete, the *Denver Post* reported:

> *The downtown area has seen 5,688 residences, 2,297 hotel rooms and 2.7 million square feet of office space either added or under construction since 2008. Two dozen projects worth $1.8 billion are expected to be completed this year alone, a third of them located in the Central Platte Valley.*

In addition to the nearby booming development, the Regional Transportation District created a Work Initiative Now Program, which in turn created 225 jobs associated with the hotel, restaurants and retail.

Several politicians alluded to the impact this project would have on Denver back in an article in the *Denver Post* on February 6, 2010, when grants were awarded to fund the project:

> *U.S. Sen. Michael Bennet told the crowd of dignitaries gathered near the tracks west of the historic station that the redevelopment project and related construction of FasTracks rail lines "conservatively could create 10,000 good-paying jobs, not just in Denver but in Aurora, in Northglenn and throughout the metro area."*

Federal Transit Administration chief Phil Rogoff made the most important announcement:

> *A $304 million federal loan Friday gave the green light to the redevelopment of Union Station as a major Front Range transportation hub.*
>
> *"This is a historic day for Denver," said Dana Crawford, the developer credited with jumpstarting redevelopment of the historic Lower Downtown district near the station.*
>
> *"FasTracks is not only at the center of this city's vision but is also at the heart of President Obama's vision for economic recovery—putting people to work now and improving the quality of life for millions of people," Rogoff said. Rogoff also said FasTracks could function as an economic development incentive. "This project will cause many businesses to move*

to Denver because the companies know their employees will not have to sit in traffic, their employees will be home for dinner and home life," he said.

Rogoff said FasTracks will become a model across the country as the Obama administration encourages workforce development near transportation centers. "Too often, the workforce that most depends on public transit becomes gentrified and gets pushed away from the transit centers," he said. "Here, we're making one investment that will benefit people in many ways. Why not have workforce development centers close to the transit stops?"

Then Denver mayor John Hickenlooper stated, "We are the first region in the country to unanimously pass a major transportation project. This is a reflection of how important Denver considers the suburbs to be and how important they consider Denver to be."

Many deserve awards for all the effort, countless hours and planning that made Union Station what is today. There were as many as seven hundred people working on or around this project site. The Denver Union Station project has pursued Leadership in Energy and Environmental Design (LEED) Silver certification from the U.S. Green Building Council,

The Grand Hall was used as a staging area during construction. Notice the ticket office windows that would become a service window for the Terminal Bar. *Courtesy of Ellen Jaskol Photography.*

REVITALIZATION

New flooring by Colorado Floorworks for the Grand Hall. *Courtesy of Ellen Jaskol Photography.*

a certification that very few transit projects ever receive. In addition to the Regional Transportation District receiving two prestigious awards for Union Station and the Free MetroRide Award from the Downtown Denver Partnership, the Denver Union Station Transit Improvements Project was honored as the Design Build Institute of America 2014 Project of the Year after turning some twenty acres of old rail yards into a tourist destination and grand masterpiece for downtown Denver.

Denver's new living room, the twenty-two-thousand-foot Great Hall, is now filled with people who again can admire all the historic features Union Station has to offer. The transformed station can once again show off its marble walls, 2,300 columbines intricately carved into plaster arches, terra-cotta stone, Belgium black marble ticket counters, wall sconces and vaulted ceiling.

Governor John Hickenlooper said it best: "In Colorado, we don't just talk about our plans for the future, we build them."

Colorado is a top tourism destination, and this destination place allows one to experience the "spirit" of Denver and its history. The "Travel by Train" sign has significant meaning again. The 2.6 million people of Denver's metropolitan area have much to be proud of regarding this majestic $500 million redevelopment. The landmark remains an important link to Denver's

A reminder of the past: the 1880 plaque on the 1914 Beaux-Arts/Renaissance Revival center structure. *Courtesy of Ellen Jaskol Photography.*

past. "Imagine a Great City," Peña's campaign slogan in 1983, is no longer something Denver has to "imagine."

As Joel Warner of Westword once wrote:

> *The new arrivals stream across the yard, under sweeping wrought-iron canopies, through granite arches and into the cathedral-like train room: vaulted ceiling overhead, two-story windows, grand chandeliers. Lines form at ticket windows, out-of-towners stop by information desks and peruse restaurants and gift shops. Beyond it all, through the station's front doors, lies the Mile High City. Welcome to Union Station, the gateway to Denver.*

> *The only way to enjoy architecture is not just to look at it but to move around it and through it.*
> *—Kenneth Bayes*

CONCLUSION

BY BETH SAGSETTER

Denver's Union Station, and all the other train depots like it across the country, marked a turning point in overland travel. Before train travel arrived, a traveler faced traveling by stagecoach. Even after train travel was readily available and continuing as late as the 1920s, a traveler would still face finishing the last leg of his or her journey to a mining camp or other remote place in a rattling stagecoach. Traveling by train and traveling by stagecoach were like night and day.

When you stepped on a train platform, you were greeted by a courteous conductor in a snappy uniform. Not so on a stagecoach. Instead of a conductor escorting you to your seat, you faced a surly stagecoach driver who was dust-covered and irascible. Stagecoach drivers were the undisputed bosses of their rigs and the kings of the primitive back roads. They were known to be "eccentric." Their language was salty enough to be shocking to the ladies, but no one dared challenge them. Instead of being shown to your seat, you'd have to fight for a spot in the coach. As many as twenty-five people would be crammed into every corner of the vehicle, some even perched precariously on the top.

Once underway in a train car, you sat on an upholstered seat, and even the less-expensive passenger cars had a potbelly stove to heat the room. Glass covered the windows. There was no dust or mud to contend with. You could read if you liked or otherwise amuse yourself. Or be lulled to sleep by the soft *clickety-clack* of the smooth iron rails. And some of the parlor cars were truly luxurious: they were lit by lamps, with drapes covering the windows and carpeting on the floors, and decorated in high Victorian fashion. It was

a lot different on the stage. These vehicles were cold in the winter and hot in the summer. The dust was suffocating, and swarms of flies were a real threat. The ride on these rough wagons was so rough that passengers and/or luggage were often tossed out and onto the ground when they hit a bump on those primitive roads. The stagecoach driver barked orders at the passengers, especially when they were underway and encountered a steep slope or other problem. Passengers would be ordered out of the wagon and forced to walk up the slope to help the exhausted horses up the incline. Sometimes the male passengers would even have to push the wagon out of bogs or up the steep areas. One passenger groused that it was the last straw to have to pay seven dollars for the privilege of riding the stage.

The contrasts were even more noticeable when it was time to eat. On a stagecoach, you'd have to wait until the next stage stop where they changed out the horses. You would face a cheerless log cabin surrounded by wilderness. You'd shake off the dust that covered every inch of your person and attempt to clean up a little. A basin and a pitcher of water awaited you and the other passengers. Along with the basin was a bar of soap and a soiled towel on a roller that turned without end. Passengers might also avail themselves of a mirror, combs and brushes, all attached by a long string so one couldn't walk off with it. Even a communal toothbrush was provided for the passengers' convenience, also attached by a string. The stage stop provided the best it could in such a wild place: an indifferent meal of stale coffee, bacon, beans and biscuits or flapjacks. To a foodie's dismay, it was a meal that would be repeated at each stage stop along the way.

On a train, you could proceed to the dining car for an elegant meal on fine china if you were hungry. The railroads prided themselves on the fine-dining experience they provided for their guests. The food was of similar caliber as at the best hotels, with silver flatware, tablecloths and uniformed waiters.

Arriving at Denver's Union Station was the high point of the entire trip. Greeting the traveler was the largest building of its time: a Gothic Revival structure with a massive arch and tower that dominated the center and were the hallmarks of that style. The central wooden clock tower was more than 180 feet high and was flanked by substantial wings on either side. Tall, narrow windows lit the spacious interior.

The central arch entryway of this magnificent structure beckoned you. Passing through the entrance doorway, you would walk between Scotch granite columns. The Gothic Revival style was continued on the inside.

CONCLUSION

The ceilings were several stories high, the floors of pink-colored lava stone. Columbines, the state flower of Colorado, were the dominant décor. Excitement filled the air. You would take in all the grandeur and refinement.

The Denver Union Station, and all the others like it, represented a new world of travel at that time—a civilized and luxurious world that replaced the rough-and-tumble world of overland stagecoaching. It reached a level of elegance that no longer exists today, certainly not at modern airports. It can be experienced now only in these magnificent old buildings that have been saved from the wrecking balls. They are living reminders of this grand era of travel. It is wonderful that this gem from the past can be restored to its position as the heartbeat of Denver.

UNION STATION PROJECT AWARDS, 2014-2015

For its regional and urban design work during the renovation of historic Denver Union Station in Lower Downtown Denver and "setting a new standard for sustainability," Skidmore, Owings & Merrill (SOM), RTD FasTracks, Denver Union Station and DUS received the Neighborhood Transformation Award (American Institute of Architects AIA).

RTD and SOM also received the National Award of Excellence in steel frame design from the American Institute of Steel Construction.

For DUS transit improvements, RTD & Kiewit Infrastructure Co. received the National Award of Merit in Transportation (other than aviation) from the Design-Build Institute of America (DBIA) for design-build project delivery for excellence in design, process and teaming.

RTD FasTracks received the Project of the Year Award for Large Transportation by the American Public Works Association (APWA) for innovations and scope of work for public works relocations, drainage and infrastructure; the Downtown Denver Partnership co-award with USNC, USA and DUSPA; and the International Partnering Institute Project of the Year Award.

Union Station/RTD was honored with three awards from Engineering News Record (ENR), including Best Project in the category of Transit/Airport for design-build innovation; Best Overall Project in the Mountain States Region for overall project excellence; and best project for "Safety."

RTD received the Alliant Build America Award & Marvin M. Black Partnering Excellence Merit Award for Construction and Partnering and the Engineering Excellence Award for engineering excellence and innovation.

USNC, in conjunction with Trammell Crow Co. and the Union Station Alliance, received the Alliant Build America Award & Marvin M. Black Partnering Excellence Merit Award for Construction and Partnering.

TIMELINE FOR DENVER'S UNION STATION

1858	William Green Russell's party found gold along Cherry Creek, starting the Pikes Peak Gold Rush.
April 23, 1859	The *Rocky Mountain News* published its first newspaper.
1862	John Evans became territorial governor.
1864	The Cherry Creek flooded Denver.
1867	Denver became the state capital.
June 24, 1870	The first train arrived in the city. The Denver Pacific Railroad line was completed to connect Denver with Cheyenne. The Kansas Pacific Railroad pulled into Denver.
1871	The Denver and Rio Grande Railroad track was laid southward.
1875	Silver was discovered in Leadville.
1876	Colorado became the Centennial State, the thirty-eighth states to be admitted to the Union.
1880	The Denver and Rio Grande laid tracks to Leadville.
June 1, 1881	The new depot was completed.

1883	Buffalo Bill's Wild West show began its thirty-year tour, and Theodore Roosevelt visited the West for the first time.
1886	The Denver Union Stockyards were established, receiving more sheep by train than anywhere else in the nation.
1887	The first train arrived in Aspen.
July 4, 1890	The state capitol cornerstone was laid, and Telluride was first to transmit AC power.
1891	The Oxford Hotel was completed.
1892	The Brown Palace Hotel was completed.
November 2, 1893	Colorado women earned the right to vote.
1894	The state capitol was completed. On March 18, a destructive fire burned Union Station.
May 11, 1894	Over three thousand Pullman Palace Car factory workers went on strike in Illinois.
1899	The first automobile came to Denver by train.
July 4, 1908	The Welcome Arch was dedicated by Denver's mayor.
1910	The first airplane landed in Denver.
1915	The new center section at Union Station was completed.
July 10, 1915	The Liberty Bell arrived at Union Station.
April 6, 1917	The United States declared war on Germany.
1918	Over 125,000 Colorado citizens registered for the draft (World War I).
November 11, 1918	Armistice Day: World War I came to an end.
May 5, 1925	U.S. Mail was flown out rather than being transported by train for the first time, although mail continued to be carried by train until about 1967.
1927	The Moffat Tunnel was completed.
1929	Denver Municipal Airport opened.
1929–35	The Great Depression.
1931	The Welcome Arch was dismantled.

1933	The Castlewood Dam broke, flooding Denver and Union Station.
1937	The U.S. Army Air Corps was established at Lowry.
1942	Camp Hale was established to train troops for World War II.
May 7, 1945	The World War II battle ended in Europe when Germany surrendered at Reims, France. Colorado lost 3,500 soldiers.
1953	The "Travel by Train" neon sign was erected in an attempt to compete with airline travel.
1967	Only twenty-three passenger trains ran per day, compared to eighty trains per day during World War II.
1971	Amtrak took over operation of passenger train service.
1974	Union Station was listed on the National Register of Historic Places.
1982–86	Extra tracks were removed from behind the station because they were no longer needed; there were thirty-five tracks but only five railroads.
1988	Demolition, or potential plans to move the station closer to the stockyards, threatened Union Station.
1992	The *Denver Post* Cheyenne Frontier Days train was operational again.
August 2001	RTD purchased the Union Station site.
May 2002	The Denver Union Station project began when RTD, the City and County of Denver, the Colorado DOT and the Denver Regional Council of Governments partnered to develop a master plan for Union Station.
November 2004	The RTD FasTracks rail network was approved by voters.
2006	The Union Station Neighborhood Company JV selected as master developer team.

TIMELINE FOR DENVER'S UNION STATION

2008	The Denver Union Station Project Authority was selected to manage and finance the redevelopment project.
2009	The last Ski Train departed the station, and the Kiewit Western Company was selected as the design-build contractor for the transit portion of the revitalization project.
July 30, 2010	DOT received a $300 million grant for rail services.
2010	Construction began on the new commuter rail station.
February 2011	Amtrak moved to a temporary location to make way for construction, and the Union Station Alliance was selected to complete revitalization of the historic structure.
August 2011	The new Union Station stop on the RTD Light Rail opened.
December 2012	The historic structure was closed to the public.
November 13, 2013	Sage Hospitality announced the naming of the Crawford Hotel.
February 2014	Construction was completed on the station's former rail yard transit element.
May 9, 2014	The Union Station bus concourse opened.
May 11, 2014	The Market Street station closed.
July 11, 2014	The sold-out Great Hall Gala was held.

BIBLIOGRAPHY

Books

Albi, Charles, and Kenton Forrest. *Denver's Railroads: The Story of Union Station and Railroads of Denver, Colorado.* Golden, CO: Railroad Museum, 1986.

Arps, Louisa Ward. *Denver in Slices.* Athens, OH: Swallow Press, 1959.

Colorado Genealogical Society, Inc. *Colorado Families: A Territorial Heritage.* Denver, CO, 1981.

Dorsett, Lyle W. *The Queen City: A History of Denver.* Boulder, CO: Pruett Publishing, 1977.

Engle, Morey, and Bernard Kelly. *Denver's Man with a Camera: The Photographs of Harry Rhoades.* Evergreen, CO: Cordillero Press Inc., 1989.

Forrest, Kenton, and William C. Jones. *Denver: A Pictorial History.* Boulder, CO: Pruett Publishing & Pruett Press, 1973.

Goodstein, Phil. *The Seamy Side of Denver.* Denver, CO: New Social Publications, 1993.

Hafen, Leroy R. *Colorado and Its People: A Narrative & Topical History of the Centennial State.* Vols. 1&2. New York: Lewis Publishing Co., n.d.

Kreck, Dick. *Denver in Flames: Forging a New Mile High City.* Golden, CO: Fulcrum Publishing, 2000.

Monahan, Doris. *Destination: Denver City—The South Platte Trail.* Athens: Swallow Press/Ohio University Press, 1985.

Nelson, Sarah M., Richard Carrillos, Lori E. Rhodes and Bonnie J. Clark. *Denver: An Archaeological History.* Philadelphia: University of Pennsylvania Press, 2001.

BIBLIOGRAPHY

Noel, Thomas J. *The City and the Saloon: Denver, 1858–1916.* Boulder: University Press of Colorado, 1996.

———. *Denver: Rocky Mountain Gold.* Tulsa, OK: Continental Heritage Press, Inc., 1980.

———. *Denver's Landmark's & Historic Districts: A Pictorial Guide.* Boulder: University Press of Colorado, 1996.

———. *Mile High City: An Illustrated History of Denver.* Denver, CO: Heritage Media Corp., 1997.

———. *Riding High: Colorado Ranchers & 100 Years of the National Western Stock Show.* N.p.: Fulcrum Publishing, 2005.

Noel, Thomas J., and Stephen J. Leonard. *Denver: Mining Camp to Metropolis.* Boulder: University Press of Colorado, 1990.

Perkin, Robert L., and Gene Fowler. *1859–1959 The First Hundred Years: An Informal History of Denver and the* Rocky Mountain News. New York: Doubleday & Company, Inc., 1959.

Pierson, Francis J. *Getting to Know Denver: Experiencing Denver's History through Architecture.* Denver, CO: Charlotte Square Press, 2006.

Reich, William L. *Colorado Industries of the Past.* Boulder, CO: Johnson Books, 2008.

Sandoval-Strausz, A.K. *Hotel: An American History.* New Haven, CT: Yale University Press, 2007.

Smiley, Jerome. *Semi-Centennial History of the State of Colorado.* Vols. 1&2. Chicago: Lewis Publishing Co., 1913.

Spencer, Elma Dill Russell. *Russell & Gold.* Austin: University of Texas Press, 1966.

Stone, Wilbur Fiske. *History of Colorado.* Vol. 2. Chicago, IL: S.J. Clarke Publishing Co., 1918.

Student, Annette L. *Denver's Riverside Cemetery: Where History Lies.* San Diego, CA: CSN Books, 2006.

Vallier, Myron. *Remembering Denver.* Nashville, TN: Turner Publishing Co., 2010.

Westermeier, Clifford P. *Colorado's First Portrait: Scenes by Early Artists.* N.p.: University of New Mexico Press, 1970.

Zamonski, Stanley W., and Teddy Keller. *The '59ers: Roaring Denver in the Gold Rush Days.* N.p.: Stanza-Harp, n.d.

BIBLIOGRAPHY

NEWSPAPERS, MAGAZINES AND OTHER SOURCES

About.com. "George Pullman, 1831–1897: The Pullman Sleeping Car." http://inventors.about.com/od/pstartinventors/a/George_Pullman.htm.

Catskill Archive. "Railroad Language-Lingo Dictionary." http://www.catskillarchive.com/rrextra/glossry1.Html.

Chronis, Peter G. "WWII's End Forever Altered City's Identity." *Denver Post*, "Snapshot of Colorado," n.d.

Colorado Genealogy History. "Colorado in World War I." http://www.coloradogenealogy.com/history1/colorado_world_war.htm.

Colorado Prospector, June 2, 1914, reprint July 1981; December 19, 1945, reprint July 1981.

Colorado Railroad Museum. "Black on Track." Advertisement, n.d.

Denver Hotel Bulletin, December 22, 1917. Collections of the Colorado Historical Society.

Denver Post, February 15, 1915; November 28, 1915; July 28, 1940; August 1, 1950; August 20, 1981; May 19, 2004; August 21 and 24, 2005; September 27, 2005; December 27, 2005; February 6, 2010; November 20, 2011; December 15, 2011; June 3, 2014; September 8, 2015.

Denver Times, June 15, 1902.

Denver Union Station 100ᵗʰ Anniversary, 1881–1981. Intermountain News, Intermountain Chapter National Railway Historical Society, July 25, 1981.

Department of Research and Investigation of the National Urban League for the Denver International Committee. *Negro Population of Denver: A Survey of Its Economical and Social States*. 1929.

Havey, Jim. *Denver Union Station: Portal to Progress*. Documentary. Havey Productions, 2010.

Iron Horse News (Winter 2015). Colorado Railroad Museum Publication.

Jackson, Steve. "The Other Side of the Tracks." *Westword*, August 2, 1995.

Metropolitan, September 10, 1890.

Rocky Mountain News, September 14, 1871; July 3, 1881; March 18, 1894; December 6, 1931; May 17, 1975; March 9, 1980; July 20, 1981; February 6, 1983; October 13, 1985; October 16, 1987; July 24, 1989; December 11, 1989; October 27, 1990; September 10, 2000; May 12, 2001; April 24, 2004; September 8, 2006; November 4, 2006; February 2, 2009.

Tonge, Thomas. *The City of Denver*. N.p., n.d.

Union Pacific: Past and Present. "Job Descriptions." https://www.up.com/aboutup/history/past-present_jobs/index.htm.

BIBLIOGRAPHY

Union Station Clocks to Begin Ticking Again! Mailgram, Intermountain Chapter National Railway Historical Society, June 1, 1978.

Warner, Joel. "The Station Agents." *Westword*, August 14, 2008.

Whaley, Monte. "Denver & The West." *Denver Post*, "Black on Track," February 15, 2015.

INDEX

INDEX

INDEX

INDEX

INDEX

INDEX

INDEX

ABOUT THE AUTHOR

Rhonda Beck, a current member of Colorado Preservation, Inc.; Historic Denver, Inc.; History Colorado; the Denver Architecture Foundation; and the Institute of Classical Art & Architecture, has lived in Denver since 1977. She found her new passion for Colorado history after attending Bill & Beth Sagsetter's Western History Field Trip to Tom Boy Mine in 1986. For the next fifteen years, Rhonda and a partner, Dan Crumb, facilitated and organized similar annual field trips to mining camps and ghost towns in Colorado. Prior to the field trips, they taught others how to use Denver Public Library's Western History Department to research the history of the people, events and artifacts of the area.

In 2003, Rhonda got involved with the research for the Historic Denver, Inc. *Historic Denver Guides*, which resulted in the publication of the *Northwest Congress Park Neighborhood* book in December 2004.

ABOUT THE AUTHOR

Hooked on Denver's fascinating history, Rhonda started research on the old hotels that once existed in downtown Denver, an interest that came about from seeing hotel guest lists and advertisements in the old newspapers while researching Congress Park articles. For nearly a decade, Rhonda has been conducting an in-depth research project on approximately five hundred early boardinghouses, rooms and hotels of downtown Denver, covering a one-hundred-year period, from 1859 to 1959. Her research includes hotel proprietors, guests and employees, as well as special parties, dinners, conventions and other historic events. Her goal is to publish a one-hundred-year history book on these historic hotels once the research is complete.

Rhonda has researched and written several historic profiles for owners of old Denver homes. She assisted Jane Daniels of Colorado Preservation, Inc. with historic and building research of the Matthews-Gotthoff mansion in Curtis Park, which enabled the general contractor of the mansion to determine which add-ons and additions to the property were historic and therefore should be preserved during the renovation.

Rhonda is a preservation advocate and is passionate about Denver's history.

UNION STATION

EST. 1881

About Denver Union Station

Denver's Union Station is the "heart of the city" and Colorado's transportation hub. The more than one-hundred-year-old building was restored and reopened in July 2014. The station offers food and beverage and retail and houses the 112-room Crawford Hotel. Named after Dana Crawford, preservationist and Union Station partner, the hotel pays homage to the building's historic past while embracing elements of Denver's future. Union Station hosts Amtrak, light rail, RTD and other passengers on a daily basis, and in 2016, the light rail from Denver International Airport will connect Denver to the world.